D1449539

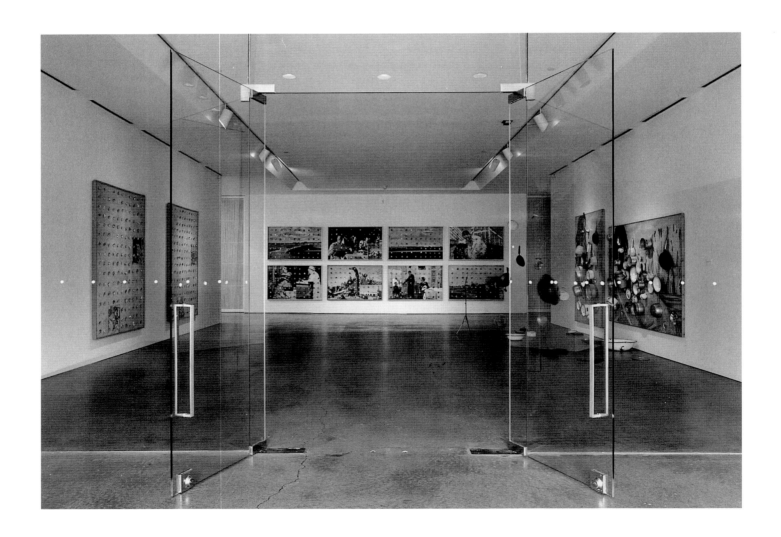

Entrance to the exhibition at the CCS Museum

Published on the occasion of the exhibition *Ilya Kabakov: 1969–1998*, presented at the
Center for Curatorial Studies Museum, Bard College, Annandale-on-Hudson, New York
June 25 – September 3, 2000

This exhibition is made possible by Robert W. Wilson and Robert and Melissa Soros

Front cover image *He Went Crazy, Undressed, Ran Away Naked*, 1981–89
Back cover image *The Concert for a Fly*, 1992 (detail)

Unless otherwise noted, all works illustrated are by Ilya Kabakov.
All photography by Doug Baz except D. James Dee, pages 34, 36, 38, 39; Don Hamerman, page 2
All installation views from the CCS exhibition

Published by the Center for Curatorial Studies
Bard College Publications: Ginger Shore, Director; Mary Smith, Art Director; Katherine Harper, Text Editor
Annandale-on-Hudson, NY 12504-5000

© 2001 Center for Curatorial Studies

PRINTED AND BOUND IN ICELAND by Oddi Printing

Contents

Foreword

In the summer of 2000, the Center for Curatorial Studies Museum mounted a solo exhibition of the work of Ilya Kabakov. What began as a modest show of mostly paintings from the John L. Stewart Collection evolved into the most comprehensive presentation to date in the United States of Kabakov's art. With characteristic enthusiasm, Kabakov designed the exhibition as a sort of "total installation," which included intimately-scaled early work such as the *Ten Characters* albums, as well as paintings and larger installations, four of which had never been exhibited in this country. As viewers moved through the galleries, they became steeped in the world of a Soviet-era ZhEK painter of banal but beautiful still life and genre paintings, the broken ideology of *The Red Corner*, and the fantasy lives of flies and little people who magically populate Kabakov's canvases.

Numerous individuals made this exhibition possible. Robert W. Wilson provided significant financial support, for which we are extremely grateful. We also extend our warmest thanks to Robert and Melissa Soros for funding this publication. John L. Stewart was a major lender to the show, and we appreciate his dedication to and knowledge of Kabakov's work. We wish to thank the anonymous lenders who so generously gave us so many of their treasures to temporarily share with the public.

At Bard College, we wish to acknowledge the continued support and encouragement of President Leon Botstein and Executive Vice President Dimitri Papadimitriou. The staff of the CCS Museum performed with its usual dedication and skill in planning and installing this complex exhibition. Major thanks go to assistant director Marcia Acita, administrative assistant Ellen Hobin, and assistant registrar Samantha Pawley for going the extra mile. Preparator Nick Nehez and the crew of Chad Kleitsch, Rick Harman, Mike Ciccone, and Stephen Rhoades worked tirelessly and accomplished last-minute installation miracles, as did ace carpenter Mark DeLura. Particular thanks go to Xan Palay and Katherine Chan for their crucial help. I am grateful as always to Norton Batkin, director of the graduate program, for his support.

For their work on this publication, we thank Ginger Shore, director of the Bard Publications Office, as well as Katherine Harper for her editorial expertise and Mary Smith for designing the book. We are fortunate that author and Kabakov expert Amei Wallach contributed an excellent text to the catalogue.

Emilia Kabakov deserves special thanks for her important contributions to all aspects of the exhibition.

Finally, we thank Ilya Kabakov for the energy, intelligence, and creativity he brought to the design and installation of the exhibition.

Amada Cruz
Director, Center for Curatorial Studies Museum

Ilya Kabakov: All the Reality That Humankind Can Bear

Do not be misled by the time frame so specifically designated in the title to the exhibition *Ilya Kabakov: 1969–1998*. The artist mixes his tenses with impunity: time past is present in time future, and time present in the past.[1] For Kabakov, time is merely one more malleable element to manipulate in his work, like light, space, color, form, narrative, traffic patterns, and debris.

The exhibition, at the Center for Curatorial Studies and Art in Contemporary Culture (CCS) at Bard College in the summer of 2000, was particularly notable for the early work it contained, much of which had never been seen in the United States. But the early work was installed in a setting that pointed to the future. The earliest paintings in the exhibition were executed in Moscow in 1969, at a moment when life in the Soviet Union seemed hopelessly at a standstill, when there seemed to be no possible future that did not include the present facts of dreariness, despotism, and deprivation.

Ostensibly the most recent work on view was the 1998 model for *The Palace of Projects*, a monumental 45-foot-high, 75-foot-wide walk-in sculptural installation housing the miniature plans for sixty-five utopian projects. (The actual, full-sized *Palace*, signed by both Kabakov and his wife, Emilia, was concurrently on view at the 69th Regiment Armory in New York City.[2]) In fact, however, the most recent work in *Ilya Kabakov: 1969–1998* was the exhibition itself. Kabakov braided the more than fifty disparate works together so that they led viewers on a psychological, ontological, aesthetic journey, at the end of which they emerged dazed by the onslaught of images and information and possessed of altered perceptions of art, history, and their relationship to both. He created an exhibition as Total Installation.

"Total Installation" is Kabakov's phrase, and he is chief theoretician of the artistic practice it designates. He defines it as a visual *gesamtkunstwerk* ("integrated artwork"), a concept formulated in the nineteenth century by composer Richard Wagner to describe an art form in which opera was the foundation upon which an integrated experience of music, drama, and visual pyrotechnics was built.[3] Kabakov has inverted the formula so that the foundation is visual, although painting serves a subordinate structural role, equal to that of music, narrative, drama, and lighting effects. In the cases of both Wagner and Kabakov, however, the enterprise is the same: to entice the viewer into a world of the artist's own making, in which everyday expectations are overturned and it becomes possible to enter into altogether unfamiliar physical, psychological, spiritual, and intellectual territory. Kabakov does so by building a series of corridors or rooms, often entered through an old, scuffed door, that transport the viewer into a new reality. He takes care to ensure that these spaces require a great deal of time to examine and that they arouse a welter of ideas and emotions before the bemused spectator exits. San Francisco artist Bruce Conner has described a similar relationship to time and

expectation in his own work: "You can't absorb the whole thing and what you've just seen changes what you see next, and when you go back to what you looked at before it doesn't look the same."[4]

It is important to Kabakov that in his alien world of installation the viewer remain in a constant state of tension between critical awareness of the apparatus of artmaking and surrender to the magic of the situation. Kabakov wants his viewer (always a "he" in the artist's writings) simultaneously to note that a white painting is a slapdash arrangement of paint on masonite and be drawn by that white painting into a state of mystical reverie. He wants the unfamiliar spaces, and the stories of half-mad dreamers they evoke, both to instruct the viewer in people, places, and ideas foreign to him, and to induce in that same viewer personal memories and associations that bring inexplicable, intimate connections into play.

Kabakov's analogy is to literature, not only because he is at heart a teller of tales, but because literature encourages a situation in which the reader is both caught up in the story and aware of the author's technique. For this reason, he incorporates a great deal of text in his work. This has many purposes, not the least of which is to slow viewers down so that they will take the necessary time to be submerged in his installations. (In general, European viewers are more amenable than hurrying Americans to such delaying tactics.) Kabakov points out that reading a book or attending the opera takes hours, whereas most viewers pause for mere seconds before a painting. How can enchantment happen under such brisk circumstances? His ambition is for his works to be as successful as are theater and film at creating illusion. Only then can Kabakov's "mechanism of 'double' action work—the experiencing of the illusion and *simultaneously* the introspection on it."[5] To encourage

such introspection, the written texts offer information, interpretation, and baldly misleading scientific and political analysis, not to mention a minute-by-minute projection of the viewer's thoughts. Kabakov refuses to assign any one species of thought more insight than another; it is all equal babble, whether educated or absurd, all someone's internal universe at work. The texts operate much in the manner of one's mind, hopscotching from vagrant contemplation of some unfinished task to awareness of one's own ignorance to an attempt at serious analysis, however wrongheaded.

A pertinent expression of text as the dialogue in a viewer's head is *Monument to the Lost Glove*, which made its first appearance in 1996, as a temporary public sculpture in a triangle of sidewalk where Broadway and Fifth Avenue cross at 23d Street in Manhattan. At Bard College, *Monument to the Lost Glove* stood outside the Center for Curatorial Studies, at the edge of a wide swath of lawn. Nevertheless, there, as in the city, one came upon the installation unexpectedly, unable to make sense of its elements from afar. Close up, one could discern that on the ground was what looked like an abandoned red glove, the red a satisfying counterpoint to the green grass. It was surrounded, as if by a small crowd of people, by a ring of nine aluminum music stands. On each stand was a text translated into four languages—Russian, French, German, English[6] —describing a fictional onlooker's rumination stimulated by the glove. In one, its "harmony of pure color" called Renoir and Monet to someone's mind. Someone else wondered whether to pick it up. A critic fumed against installations as "talentless frivolities." The glove aroused a childhood memory of a grandmother's roses, a bittersweet reminiscence of a tryst and a parting, the recollection of a crime in which a gray glove played a role, tears over past losses.

Someone noticed that the glove was, after all, not a glove at all, but only a plastic replica of one, and derided the postmodern age of imitation in which genuine values have given way to "murky shadows among other shadows." As one stood there, part of the circle, the cacophony in one's own head mingled with these other, imaginary voices. By the simplest of means, Kabakov had closed off the outside world as if with the walls of an installation, and created a clamorous, intimate space—in fact, a Soviet space.

When Kabakov first began to develop the concept of Total Installation in the 1980s, he was living in a studio he had constructed on the roof of 6/1 Sretensky Boulevard, a historic edifice that the French architect Le Corbusier once called "the most beautiful building in Moscow."[7] After the Russian revolution, the building had been converted from an apartment house for the wealthy into a squalid stack of communal flats. These still exist in Russia today, a decade after the fall of Communism, noisome evidence of the difficulties of daily life under the Soviet system. The result of a dearth of adequate housing, they were meant to be a stopgap solution on the way to a glorious future; instead, they became the overwhelming fact of what appeared to be an interminable present. Each apartment consisted of a kitchen, hallway, and toilet shared by generations of as many as twenty extended families, each of whom inhabited a room off the corridor, nine square meters per human being. As if such forced intimacy were not loathsome enough, there were official committees within the apartment and a bureaucratic oversight apparatus without it to make life yet more intrusive and impossible. A registration permit was necessary in order to reside in any given apartment, and the police vigilantly enforced the law. If the police were lax, there was always an envious neighbor to inform and a housing authority, ZhEK, to manage the physical premises as badly as possible and to monitor tenant irregularities with obstinate zeal.

Kabakov was not at that point permitted to show his works publicly, so only fleeting and incomplete versions of his first installations were mounted from time to time for friends in his studio. The communal apartment was his metaphor for the inchoate, layered inadequacies of Soviet life. In making his installations, he sought to understand for himself the realities of art and life in the Soviet Union and engage his friends in an artistic and philosophical dialogue on the relationship between the two. It was his endeavor to dig through the layers of official lies and bureaucratic language with which the government and its legions of servants sought to obfuscate the actualities that every Soviet citizen lived. Even at home, even in the communal apartment under the watchful eye of committees and petty officials, the language of private life was the language of the state. It was the way people spoke together when they quarreled in the kitchen, or wrangled over toilet rights. It became the language of their dreams and their seductions, making real emotions impenetrable and authentic responses problematic.

Once Kabakov arrived in the West, after 1988, the voices from within the communal apartment became the language he spoke through his art. He became aware of a difference in the very basic ways in which people in the Soviet Union and those in the West moved through space. In the Soviet Union, every space—the kitchen, the bedroom, the sports club, the hospital, the police station—was utterly different, if not in the muddy brown or green paint on the walls, then in the essence of its particular atmosphere. But everything within that space—the makeshift desks, the dirty, unshaded light bulbs, the scuffed chairs, the threadbare jackets—was alike in

its interchangeable shoddiness. In the West, it was just the opposite: all spaces seemed to be clean, well lit, and anonymous, whereas the objects that inhabited them—vacuum cleaners, television sets, reclining chairs, dentist's drills, conference room tables, pinstriped suits, sneakers—were specific, separately designed, and individual in their uses. Those well-functioning "millions of objects surrounding a person that help him to live and work—completely fill up his life every day and cling to his body and even, as they say, to his soul."[8]

In his installations, Kabakov employed the atmospheric space of the Soviet Union and the born-to-shop attention to objects that Westerners learned from birth. He created dimly lit corridors and rooms out of the communal apartment and the Soviet nightmare, but cluttered with objects and texts that, no matter how shabby, museum audiences would pause to examine. By inviting Western viewers into the closed world of Soviet space—and in particular the communal apartment, with all its petty quarrels, thwarted dreams, and murderous intensity—he could entice them to experience something of the commonplace horror of Soviet life. And he could do so with an irony and burlesque humor that did nothing at all to mitigate its monstrousness, but made it accessible to people who could never imagine such a situation on their own. In fact the hapless characters whose leavings supposedly furnished the rooms of his communal apartments struck a chord in the viewer, who could make connections between childhood experiences and those suggested by the art. The pasts of the communal apartment dweller and of the viewer became intertwined. The viewer was transfixed in a moment of memory and expectation that was altogether present. It became essential to advance to the next place in the installation, as in the stations of the cross, to experience what came next. Traversing the installations became an occasion for empathy. The Soviet condition became the human condition; an unthinkable reality became, if not bearable, at least comprehensible. On the other hand, since each character in the ten rooms was an artist or a dreamer engaged in a different aspect of Kabakov's technique, he was putting his art practice to the test in a Western situation.

In the years since, during which Kabakov has become one of the most celebrated artists in the world, he has mounted 165 installations in 148 museums in thirty countries. Museums are different from most other spaces in that they are idealized and venerated; we expect of them something more profound than entertainment, something instructive or uplifting. In recent years, the museum has begun to supplant the communal apartment as Kabakov's universal metaphor and the space of his installation. The bare bulbs and dirty walls of the earlier works have become white display areas washed in light. It is to such places, museum spaces filled with objects, that we in the West bring our aspirations and our dreams. *The Palace of Projects* was a monumental shining white spiral, sheathed in permeable white fabric. The sixty-five utopian dreams inside were organized like a museum exhibition.

But the apotheosis of Total Installation as museum exhibition is an exhibition itself. This was the case with the *Ilya Kabakov: 1969–1998* show at Bard College. Through a set of glass doors from the museum's lobby, one entered a wide central space, to the right of which was a 1988 installation, *Incident in the Corridor near the Kitchen*, and to the left, two large paintings from the artist's 1987 *Holidays* series. The paintings are among the last that Kabakov completed before making his first visit to the West, the installation among his first created outside the Soviet Union.

Incident in the Corridor near the Kitchen is not yet a Total Installation, for one cannot walk through it, although it reaches into the viewer's space. It consists of two paintings, one horizontal, one vertical, both extremely rudimentary Cézannesque landscapes in a palette of greens and blues. In front of them, from transparent plastic strings, hang pots, colanders, scrapers, tin cups, frying pans, unmatched lids, pails, all dented, rusted, scratched, and old. A text on a music stand informs the viewer, "When Olga Nicolaevna came to the kitchen in the morning, she saw in the corridor numerous pots, pans, and plates, which were flying in the air." The image is at once horrifying and magical, comical and beautiful. They are terrible old pots and pans and the communal kitchen from which they have flown is worse. But the point is that they fly—they fly away, out of the communal kitchen and into a landscape inadequately imagined by the very bad painter that the ZhEK has employed to decorate.

The kitchen was the core of the communal apartment. Imagine all those people finding room for their pots, jostling for space at the sink, negotiating the garbage, protecting food; picture the operatic battles, the petty reprisals, the gang warfare between families, the relationships beginning and ending over a cup of tea. Kabakov has described the communal kitchen as "the city square of the Middle Ages, and a theater where the audience and the actors change places."[9] Insofar as there was such a thing in Kabakov's Soviet Union, the communal kitchen was also home, something that he himself did not actually have for most of his boyhood.

The artist's mother, Bertha Solodukhina, was the child of a father who spoke only Yiddish and a mother literate only in Hebrew. (All his Soviet life, the artist's internal passport read "Jewish" rather than "Russian," for which reason he has never considered himself a Russian citizen.) His father, Joseph Kabakov, had insinuated himself into Bertha's life, first as a tenant, then a bullying husband who forced her to have an abortion the first time she became pregnant. The second time, she insisted on giving birth. Ilya Josifovich Kabakov was born on September 30, 1933 in Dnepropetrovsk, Ukraine, in the midst of a famine so severe that as many as five million of his countrymen died of hunger that year.[10] It was starvation brought on by both Stalin's policy of farm collectivization and governmental punishment of the region in which farmers were least eager to cooperate. But to utter the word "hunger," let alone "famine," was to risk imprisonment or death[11]: Stalin had already established the corruption of language that would become one of the central themes of Kabakov's art.

Terror and adoration of Stalin comprised the atmosphere in which the boy grew up; privation was a fact of daily life. Then, on June 22, 1941, when Kabakov was seven, three million German troops invaded the Soviet Union in a three-pronged blitzkrieg supported by 2,770 aircraft. Stalin had signed a nonaggression pact with Hitler, so the Soviet Union was altogether unprepared for the attack. Dnepropetrovsk was already under fire when the Kabakovs and much of the rest of the populace fled east over the only bridge across the Dnieper River, bombs falling, machine guns rattling, a train filled with troops and dignitaries plowing through their midst. By cart, by boat, by train, by foot, the Kabakovs eventually arrived in Samarkand and settled in a crowded Uzbek cottage of mud brick, with donkeys, sheep, and chickens in the courtyard. It was here that young Ilya Kabakov became an artist, as if by accident.

The boy had always won himself friends by drawing, but one day in the autumn of 1943, he sketched a panzer, an airplane, a ship, and a horse with a black pencil, and signed his name to them

in enormous red letters. Amused, the admissions committee for the Leningrad Institute of Painting, Sculpture, and Architecture of the All-Russian Academy of Arts accepted ten-year-old Kabakov into their primary school. (Leningrad was then under siege, and the Institute had been evacuated to Samarkand.) By the time the German armies were defeated and the two-year siege lifted on January 27, 1944, as much of a third of Leningrad's populace had starved to death. Three trainloads of officials, factory personnel, and students and teachers of the Institute departed Samarkand for Leningrad, via Moscow. Along the way, Kabakov transferred to the Moscow School of Art and moved into its dormitory. His mother, however, did not have the papers necessary to stay in the city. In Zagorsk, more than 50 miles distant, she daily queued up for rations so that she could cook him borscht, took the long train ride to Moscow, and ate with him—though he was ashamed of her by then, and guilty that he felt such shame. When she lost her permission to live in Zagorsk, she became a homeless wanderer in the capital, first living in a flophouse for janitors, then on a table in an office, then in an abandoned bathroom. For a time, she took up illegal residence on a cot someone rented out during the day in a communal apartment, until a neighbor reported her and the police came in the middle of the night to check documents.

Meanwhile, in school, Kabakov was being instructed every day in every way that he was living in "paradise," though in fact his dormitory was a terrorism machine in which the older boys bullied the younger. It was impossible to reconcile what one was told to believe with what one experienced, difficult to trust what one saw with one's own eyes. It was also dangerous to say what one meant, so no one did; everyone tried to blend. Kabakov remembers the mechanism necessary to survive in the Soviet system as speaking two languages: one for public consumption and a second, contradictory interior one. "The second language controls the first, and makes it ironic," he says. "It is like a play, but there is no stage, it is life. . . . The normal Soviet man must appear very tolerant, friendly, happy, positive; he speaks very carefully, but very exactly. . . . I can say I am a typical Soviet character, but with only one difference: I observed that character well."[12]

By the time Stalin died, in 1953, Kabakov was a student at the Surikov Institute of Art, the most prestigious art school in the Soviet Union. He was receiving rigorous training in classical techniques from the most honored artists in the country. But the end to which his teachers put this proficiency, and for which Kabakov was being prepared himself, was Socialist Realism. Artists were expected to participate in creating a new Soviet humanity by making narrative, realistic paintings that promulgated the Communist dream and glorified Soviet heroes with optimism and conviction. Anything that smacked of "formalism," meaning art for the sake of art, was considered a capitalist tool, and forbidden. This meant Cézanne, Van Gogh, Matisse, certainly Picasso, and the Russian avant-garde of the earlier part of the century: Malevich, Popova, Tatlin. The Surikov was a school for the gifted, something Kabakov did not consider himself to be: he thought himself inept as a painter, smarted when a schoolmate he admired dismissed him as "no colorist." He was a student in the Institute's graphic section, not the more prestigious painting section.

Not long after Stalin's death, paintings by Cézanne, Matisse, and Picasso began to tour the U.S.S.R. from abroad and appear on the walls of Soviet museums. Kabakov and his friends Oleg Vassiliev and Eric Bulatov began a quest to discover art that was not tainted with the blood of the Stalinist regime, that seemed at once to

deserve a place in Western art history and to express their own realities. To earn a living it was necessary to join the Union of Soviet Artists, then a creative worker's only source of studios, supplies, and income. But to join the painting section meant extolling the Soviet dream. They joined the graphics section instead, and Kabakov found work illustrating children's books in a style sufficiently banal and innocuous to seem safe to publishers and censors.

Under Nikita Khrushchev, a modicum of freedom entered Soviet life—the "Khrushchev thaw," people called it—and in the late 1950s, an underground artistic community began to grow. However, in 1962, Khrushchev himself seemed to betray the movement by attacking an exhibition that included underground artists at the Manége, Moscow's central exhibition space. After that, Kabakov's life became increasingly difficult, and so did the making of authentic art. He survived by making children's books for others, and secret art for himself.

In the late 1950s and early 1960s, artists all over the world were intent on tearing down the barriers between art and life, in using the language and the materials of the streets to make work that reflected on real situations, an anti-art. In the Soviet Union, news from the outside art world still was almost inaccessible. Nevertheless, beginning in the early 1960s, Kabakov began employing the actualities of his everyday life as tools for artmaking. He used debris from the streets to construct paintings, the banal style of his children's book illustrations and "nonsense that came into my head"[13] to make drawings. He began to take note of the omnipresent placards advertising meat that everyone knew was unavailable, construction that everyone was aware would never happen, the endless lists of things to do and people to do them in the communal apartment. He used house paint on Masonite to ape the look of things in the real world, made images that questioned authenticity at every level—physical, metaphysical, artistic—and toyed with the implications.

By the early Seventies, clusters of artists (later known as the Moscow Conceptualists) had begun to come together in the capital city. Kabakov was at the center of the Sretensky Boulevard group, named for the street where he and his friends lived. It was an extraordinarily rich period for artists, not unlike that experienced in New York by abstract-expressionist painters and sculptors in the 1940s. The outside world did not know who they were, but the musicians, poets, writers, artists of the new avant-garde recognized one another and gathered at every possible opportunity. In this "infinitely happy and joyful period of stormy, insane gatherings in my studio,"[14] Kabakov began work on the series of sixty-two albums that are at the heart of his work. He started, between 1969 and 1974, with the central cycle of ten albums, 10 Characters, which was on view in please-touch facsimile in a room off the entrance to the exhibition at the Center for Curatorial Studies.

The 10 Characters albums are works of conceptualism that come clearly out of Russian traditions: the iconostases in Russian Orthodox churches, documenting the lives of saints; the novels of Leo Tolstoy, Fyodor Dostoyevsky, Aleksandr Pushkin, and particularly the tragicomic Nikolay Gogol. In each album, through words and pictures, Kabakov tells the story of a doomed dreamer, an artist. In each, he surveys artistic strategies of the old and new Russian avant-garde; in each, he employs text to deconstruct his story through the language of science, religion and everyman (actually, in this case, a character named Lunina, who is everywoman at her best). The albums are the Rosetta stone to Kabakov's

work. For this reason he gave them a room of their own in the exhibition, and a table, chair, and lamp for each album so that one could prepare oneself for everything that followed.

The greatest and most common horror in Soviet life, as it is in ours, was the loss of self. Kabakov's art sought to ground him, and his artmaking, in precisely the realities the characters he invented could not bear. Each album concerned itself with a character who projected an aspect of the artist's work and inner life on the outside world in so bizarre and exaggerated a fashion that in the end, the only possibility was escape into dreaming, negation, mysticism, and death.

The philosopher Boris Groys, a friend from Kabakov's Soviet days and his chief theoretician, relates the first of the *10 Characters* albums, *Sitting-in-the-Closet Primakov*, to the realities of Kabakov's own artistic situation in Moscow. No matter how close and supportive the world of Moscow Conceptualists, its denizens were altogether aware that as far as the rest of the art world was concerned, they were working in a vacuum, invisible, with no possible critical feedback and no notion of how they might be perceived in context of the international scene. "Primakov," Groys suggests, "deals with this invisibility abroad."[15]

Primakov begins with a black square, à la Malevich. Kabakov's relationship to Malevich is a complex one. To the West, Malevich is the anti-Soviet hero of abstraction. To Kabakov, he is the authoritarian who brooked no style but modernism and had Chagall fired from his job as a teacher. Malevich is also the high priest of absolutes. Kabakov's Soviet past and his predilection for absurdity and irony have made him forever allergic to absolutes. Malevich proclaimed his in black and white: "The blue sky has been conquered by the suprematist system, has been breached, and has passed into the white beyond as the true, real conception of eternity, and therefore has liberated the sky's colored background."[16]

So the black square in Kabakov's album is, in fact, the view from Primakov's closet, desecrated, from the first, by a dialogue box. After a few pages, Primakov begins to see more and more of his apartment; then he flies out of it, over the city, into the sky, into the semaphore (which, instead of being absolute, becomes a banner naming something so prosaic as a tomato), into the cosmos, finally disappearing into white. In each of the ten albums, the central character is afflicted with some species of impaired vision, which becomes the occasion for parody of yet another art form. *Agonizing Surikov* can only see part of the world at a time through a hole. *Decorator Maligin* sticks only to the margins and the corners, because it is dangerous in the center. *Generous Barmin* tries to control reality by naming things in lists.

In each case the character disappears into the cosmos and white.

Once Kabakov began creating Total Installations, he was apt to people them with characters from his albums or their recognizable relations. But in *The Red Corner* (1983), the most complete Total Installation in the exhibition, the viewer was the central character. The title refers to the propaganda corner in a Soviet establishment; the room one entered at the Center, through a battered door, was dark, lit by two low-wattage bulbs, disheveled and strewn with debris as if its occupants had left in a hurry. On a makeshift table in the center of the room, a paint-splattered, filthy old portable cassette recorder played Soviet songs of romance and pride, the kind of songs that can still bring tears to Russians' eyes because no matter how terrible it all was, it was their lives, after all. There was a scrap of sandpaper on the table, and a typewritten complaint from

an obvious crazy person who wanted to be "isolated from those citizens with whom I have been living for 15 years already," and another with complaints against him for "hooliganism" by his apartment-mates. There were byzantine instructions, explanations, schedules to be read, posters on the walls, proclamations, all made nearly indecipherable by the inadequacy of the lighting. Even what one was supposed to see, one could only partially see.

One escaped the room through another door, to be confronted with Kabakov's homage to his own escape, the 1989 *I'll Return by April 12th*. On the floor, like a carpet, was an oil-on-paper painting of a sky out of Tiepolo. The painting was surrounded by stanchions, a note on a music stand—"I'll return by April 12, 1989"—and, neatly folded on a wooden chair, the clothes of the man who had ostensibly flown into the painting and into the sky like a character out of the albums. In April of 1988, Kabakov had returned to Moscow for two weeks to see his family, then fled once again to the West. On his return, he had created the predecessor to his Tiepolo sky: *The Man Who Flew Into His Picture*, part of the *10 Characters* Total Installation with which the artist introduced himself to New York at the Ronald Feldman Gallery. The picture the man flew into was not of the sky; rather, it was white, at once shoddy and transcendent. The original of *The Man Who Flew Into His Picture* is now in the collection of New York's Museum of Modern Art.

In the room in the exhibition that housed *I'll Return by April 12th* were other works from the same period—paintings done as charts and tables (*The Fly and the Tabular Poetry*, 1989) plus a grouping of sunny Socialist Realist works that had been attacked with a hammer, together with commentaries meant not to be helpful but rather to transform the old art form into that new one, Total Installation (*The Artist's Despair or the Conspiracy of the Untalented*, 1994).

From this argument for installation, one advanced to a fragment from Kabakov's 1981–1989 *He Went Crazy, Undressed, Ran Away Naked*. The "he" of the title is an untalented ZhEK artist, who painted out garbage removal schedules, holiday slogans, announcements for the Red Corner, and who finally couldn't take it any more, stripped, and bolted, leaving behind murals, books, and his clothes, attached to the paintings. On tables were commentaries, books of still more comments labeled "Intellectual People" and "Common People," and helpful texts on Kabakov's work. Kabakov himself had fled to the West, but it was no shining beacon, despite the accolades he immediately received and the ability to show anything anywhere, it seemed. Daily life there was no less problematic, only different.

Kabakov's own state of mind at the time he was working on *He Went Crazy* is best signified by the installation *The Three Nights*, which he constructed during his first winter in Paris in 1988, at a moment when he seemed in transition. He had buried his mother in January, shown in New York in the spring, returned to Moscow that summer, and determined to leave forever. In Paris he was utterly isolated. He knew the word for one French dish, *poulet*, and that is what he ate every day. He was in a city of endless delights, but too traumatized to hazard any of them. He stayed in his studio. In this state, he completed three monumental and extraordinary paintings. His position toward painting had always been problematic: he had no intellectual interest in it as a form, and, he insisted, ever since being dismissed as "no colorist" as a student, had had no confidence in himself as a painter. His concern was with painting as a signifier of the inaccessibility of truth. Until the *Holiday* series of 1987, his paintings had been enamel on Masonite, employing the forms of children's book illustration

and bureaucratic announcements and lists. They raised questions about just what a painting was and whether these had any right to be called by the name; the viewer's attention flickered between suspension of belief and doubt, between context and content. By the time Kabakov arrived in Paris, he had decided that easel painting, like the medieval panel painting and altarpiece, was only one stage in art history. Just as the panel painting had been replaced by oil on canvas, so now painting's fate was no longer to stand alone, but to be incorporated, as one among many elements, into Total Installation.

Toward this end, he essentially concealed the three monumental paintings of *The Three Nights*. He built a wooden stockade and hung the paintings outside it in such a way that it was impossible to stand back far enough to see them whole. Like Primakov in his closet, one could only see them partially. One could either walk around the structure and see them too close-up, or enter the wooden structure and gaze through binoculars into a hole at an inconclusive detail. The helpful text on a table informed the viewer that the Deputy Director of the (wholly fabricated) Voronezh Picture Gallery had finally, in 1978, been able to examine the paintings, which had arrived forty years before, and had found in them tiny white figures of people; by 1982, these had shifted their positions. In Kabakov's personal iconography, the fly is an emblem of man who feeds on the garbage of memory and flies into imagination, transcendence, and despair. The little white people, by contrast, are spirits of the lost Soviet civilization, and of his past.

It was only after one had comprehended his use of painting in the 1988 installation that Kabakov permitted viewers to see his 1960s works, in the next-to-the-last room of the exhibition.

When he painted *The Russian Series* in 1969, the works themselves were equivalents of the haphazard organization of Soviet life, the prevalence of bureaucracy, the infinite negative spaces of the Soviet landscape. Kabakov's Russian paintings, as well as his green and his white paintings, are sometimes misunderstood as minimalism. They were never meant that way. They were meant to be paintings that were not paintings, that were not abstraction or realism, that were remnants of a questionable reality in themselves. How could they not be, with a nail hammered into one, a pot hanging from another, blocks of text bearing vagrant snatches of conversation or the carefully drawn columns of a communal kitchen coordinator on others? The paintings were empty, as in hopeless, meaningless, endless. Their purpose was to evoke in the viewer the boredom and despair of everyday actuality. At the CCS, Kabakov furnished explanatory texts in order to make them elements of an installation. It is in the room of *The Russian Series* that he placed the model for *The Palace of Projects*, because the Soviet experiment had taught that all utopian projects are potentially murderous. Kabakov's position is that without utopian dreams, life is insupportable, but that such dreams are dangerous unless the dreamer keeps them to himself and makes no attempt at all to foist them on anyone else.

But Kabakov himself is not so restrained in imparting opinions. He ended the exhibition with a mini-retrospective of paintings and a cautionary sermon that took the form of a 1992 version of *The Concert for a Fly*. (The full-sized *The Palace of Projects* ended with a concert for the fly, as well.) Like *Monument to the Lost Glove*, the "concert" consists of a central object surrounded by music stands. The object: a three-dimensional paper fly, slightly larger than actual size, hung from a transparent filament at eye

level. Drawings on the music stands attempt to explain every-thing—the movement of energy, the relationships of civilizations, the political structure of nations—by means of the fly, Kabakov's universal symbol for humankind and its potential for good and evil. These youthful artworks represent his one and only flirtation with abstraction, a style that never did satisfy him because it seemed too "biological," too bereft of the irony and ideas he

prized. Even so, he places this concert to humankind and to art-making in a room filled with paintings.

Questions of art and life will never be wholly settled for Kabakov, or for us. In *Ilya Kabakov: 1969–1998*, through the offices of imagination, he once again threw reality back in our faces. By means of a museum exhibition, he unsettled accepted notions of art and life.

Amei Wallach

1 This line is a paraphrase from T.S. Eliot's "Burnt Norton" from *Four Quartets* ("Time present and time past/Are both perhaps present in time future"), as is the title ("human kind/Cannot bear very much reality."

2 For the past ten years, Emilia Kabakov has been working in partnership with her husband, much in the manner of Jeanne-Claude and Christo. She is the one who makes the installations happen: organizes the troops, nego-tiates, arranges for translations (or does it herself), contributes ideas, and makes herself generally indispensible throughout the process. For that rea-son, the Kabakovs have begun co-signing installations, but never drawings, paintings, or prints, which Ilya Kabakov makes himself.

3 "In the aesthetic theory of Richard Wagner (1813–83), an ideal work of art in which drama, music, and other performing arts are integrated and each is subservient to the whole." *The Oxford English Dictionary*, Second Edition, Volume VI (Oxford: Claredon Press, 1998), 473.

4 Bruce Conner to Amei Wallach, San Francisco, August 14, 2000. Conner was talking about the dense black lines he makes with a Pentel pen in his late drawings, but the effect seems notably similar to what Kabakov strives for in his installations.

5 Ilya Kabakov, *On the "Total" Installation*, translated by Cindy Martin (Bonn: Ilya Kabakov and Cantz Verlag für die Abbildungen, 1995), 245. From a series of lectures delivered at the Städelschule, Frankfurt, 1992–1993.

6 It has become customary for Kabakov to translate his texts into so many languages because his exhibitions take place in museums around the world.

7 Quoted in Richard Lourie, "No. 6/1 Sretensky Boulevard," in David Ross, ed. *Between Spring and Summer: Conceptual Art in the Era of Late Communism* (Boston: Institute of Contemporary Art, 1990), 31.

8 *On the "Total" Installation*, 244.

9 Ilya Kabakov, *In the Communal Kitchen* (Paris: Galerie Dina Vierny, 1993), 38.

10 Robert Conquest, *The Harvest of Sorrow: Soviet Collectivization and the Terror-Famine* (New York: Oxford University Press, 1986), 306.

11 Ibid. 259.

12 Ilya Kabakov in conversation with Amei Wallach, August 6, 1992. Quoted in Amei Wallach, *Ilya Kabakov: The Man Who Never Threw Anything Away* (New York: Harry N. Abrams, 1996), 22.

13 Ibid. 40.

14 Ibid. 54.

15 Boris Groys. "The Movable Cave, or Kabakov's Self-memorials," in *Ilya Kabakov* (London: Phaidon, 1998), 44.

16 Kazimir Malevich, "Suprematism," in John Bowlt, ed., *Russian Art of the Avant-Garde: Theory and Criticism* (New York: Thames and Hudson, 1988), 143.

Checklist

10 Characters (originally produced from 1968–75)
 Album I: *Sitting-in-the-Closet Primakov*, 1994
 Album II: *The Joker Gorokhov*, 1998
 Album III: *Generous Barmin*, n.d.
 Album IV: *Agonizing Surikov*, n.d.
 Album V: *Anna Petrovna Has a Dream*, 1996
 Album VI: *The Flying Komarov*, 1994
 Album VII: *Mathematical Gorski*, 1998
 Album VIII: *The Decorator Maligin*, n.d.
 Album IX: *Released Gavrilov*, n.d.
 Album X: *The Looking-out-the-Window Arkhipov*, 1998
Reproductions of original ink and colored pencil on paper
Sheet dimensions: each 20 1/8" x 13"
The John L. Stewart Collection

The Russian Series, 1969
Mixed media installation: enamel on Masonite paintings,
table, chairs, wooden barriers, and text
Three paintings: 49" x 77" each:
 Ivan Tromfimovich Goes to Town to Collect Firewood
 In the Corner
 They Lie Below
One painting: 43 3/8" x 67"
The John L. Stewart Collection

A Piece of Meat, 1971?
Drawing on paper
12 3/4" x 11"
The John L. Stewart Collection

Children's Corner, 1980
Pencil, paint, and mixed media on paper
Twelve parts: 11 3/8" x 8" each
The John L. Stewart Collection

The Glue Escapes, 1980
Enamel on Masonite, podium, and text
104" x 76"
The John L. Stewart Collection

Nikolai Petrovich/The Untalented Artist Displays His Work For All To See, 1980
Enamel on Masonite
102" x 75"
The John L. Stewart Collection

The Untalented Artist, Hello the Morning of the Motherland, 1981
Oil on Masonite
Three parts: 102" x 74" each, 102" x 224" overall
The John L. Stewart Collection

Whose Pot is This? I Don't Know, 1981
Enamel on Masonite with mixed media
27" x 47"
The John L. Stewart Collection

Three Green Paintings, 1981–1983
Mixed media installation: enamel on Masonite paintings, table, chairs, barriers, and text
Individual painting:
 Volodja wanted to get jars in this weather?! Yes, but yesterday he brought them together in a box
 44" x 80"
 Private collection
Three paintings:
 There is still a woman
 44" x 80"
 Where are you throwing the peels?
 44" x 80"
 In the vacation zone of Sokolniki
 46" x 38"
Collection of the artist

He Went Crazy, Undressed, Ran Away Naked, 1981–89
Mixed media installation: mural on paper, enamel on Masonite, furniture, books, objects, and barriers
Four paintings:
 Schedule of Behavior of Mokushansky Family
 Plan of My Life
 Commentaries of O. Egorova
 List of People Having Rights
Overall installation: 168" h x 252" l x 120" w
The John L. Stewart Collection

Things I Must Do by March 16, 1981–89
Enamel on Masonite
94" x 149"
The John L. Stewart Collection

Over the Country, The Spring Wind is Blowing, 1983
Enamel on Masonite
Three paintings: 68" x 48", 68" x 47", 68" x 47"
The John L. Stewart Collection

The Red Corner, 1983
Mixed media installation: enamel and collage elements on Masonite, table, audio-cassette tape player, light bulbs, chairs, broom, and text
Four paintings: 62" x 86" each
Room dimensions: 41'4" x 29'8"
Collection of the artist

Holidays #2, Holidays #4, Holidays #5, Holidays #6, Holidays #7, Holidays #8, Holidays #9, Holidays #10, 1987
Oil and paper on canvas
40" x 60" each
The John L. Stewart Collection

Holidays #11, 1987
Oil and paper on canvas
78" x 60"
The John L. Stewart Collection

Holidays #12, 1987
Oil and paper on canvas
78" x 60"
The John L. Stewart Collection

Incident in the Corridor near the Kitchen, 1988
Mixed media installation: oil on canvas paintings, pots, pans, kitchen utensils, and text on music stand
Two paintings: 63" x 94" and 83" x 57"
Private collection

The Three Nights, 1988
Mixed media installation: oil on canvas paintings, wooden
structure, binoculars, tripods, table, and text
Paintings: 147" x 90", 89" x 23", 128" x 323"
Wooden structure: 90" h x 360" l x 132" w
Collection of the artist

The Fly and the Tabular Poetry, 1989
Enamel on Masonite and mixed media on paper
Painting: 94" x 149"
Forty-eight framed works on paper: 22" x 15" each
Private collection

I'll Return by April 12th, 1989
Mixed media installation: oil on paper, chair, clothes, podium,
barriers, and text
Collection of the artist

**This is How Volodja Varanov Quickly Moved from the Winter
to the Summer**, 1989
Enamel on Masonite
102" x 75"
Private collection

The Concert for a Fly, 1992
Mixed media installation: copies of drawings, wooden music stands,
monofilament, paper fly
108" diameter
Collection of the artist

Set and costume designs from the Brooklyn Academy of Music's
production of **The Flies**, 1992–1995
Six prints on paper
Set design: 20 15/16" x 25"
Five costume designs: 10" x 13 3/16" each
The John L. Stewart Collection

From the **Children's Coloring Book**, 1993–95
Drawing and prints
Five works ranging from 14" x 18" to 17" x 24" each
The John L. Stewart Collection:

The Artist's Despair or the Conspiracy of the Untalented, 1994
Mixed media installation: enamel on canvas, broken glass, axe, paper,
barriers, table, and text
Three paintings: 50" x 71" each
Private collection

Untitled, 1994
Mixed media and collage on paper
Two drawings, 24" x 30" each
The John L. Stewart Collection

Monument to the Lost Glove, 1996
Plastic glove, nine aluminum music stands, and texts
Semi-circle with 165" radius
Collection of the artist

The Meeting, 1998
Video projection
Collection of Ilya Kabakov and Jan Fabre

Ilya and Emilia Kabakov
The Palace of Projects, (model), 1998
Wood and fabric
24" h x 60" diameter
Collection of the artists

Reverse, 1998
Mixed media installation: wooden structure, Styrofoam, synthetic hair,
fabric, table, chairs, objects, lamp, and book
Approx. 114" h x 95" l x 95" w
Collection of the artist

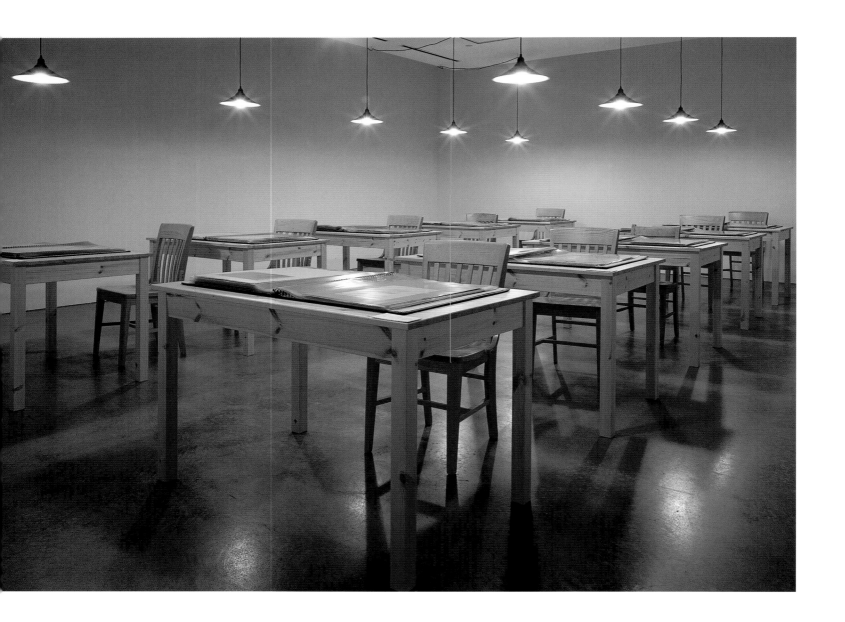

10 Characters, dates variable
Installation view

10 Characters

The Person Who Describes His Life through Characters

Once while writing his biography, he suddenly ran into a situation, which for some reason he could not attribute to the biography of one person, although it was only talking about "him," but could easily attribute to the biography of a multitude of people. He was terribly surprised and was even frightened by such a circumstance. After all, he perfectly understood that it referred to him only. Nevertheless these different personages had so unexpectedly and distinctly appeared before him, and so clear and comprehensible were their personalities that he even heard voices uttered by each one.

In order to extricate himself from this strange delusion he began to make unique albums, a special mixture of conditions, drawings, and explanations, each of which personified a certain personage, a special part of him. This is how large groups from the ten and more *Characters* appeared.

He undertook once to describe his life, mostly so that he could find out from this description who he himself was, now that he had lived more than half his life. Once he described everything calmly and circumstantially, he expected to elucidate and lay out before his memory everything which had happened during his years and thereby disclose all the events which transpired during them. But it turned out that the number of events for all these long years were not that many, in all two or three, and his whole life up to this day amounted only to all sorts of impressions connected with one or another person, thing, object. . . Recording them all consecutively without any kind of selection, he suddenly discovered that even these variegated fragments and shards belonged not to his single consciousness, his memory alone, but, as it were, to the most diverse and even separate minds, not connected with each other, rather strongly different from one another. . .

He reflected on this circumstance. What to do? On the one hand, he was one, so to speak; if he looked in the mirror and saw himself, but on the other hand, thinking about something, he saw in himself not one, but many.

He made a decision: unite all these "many and diverse" into a kind of artistic whole, but allow them to enter into arguments, outdo one another, but let all express themselves in turn. Let each of them have his right to vote completely and fully, in complete eternal silence, say everything that he knows, and tell his story and ideas to full expression. With that it would be possible to relax. With this decision he suddenly felt the cacophony, which had agitated him uninterruptedly inside since the time he resolved to describe his life, grow quiet. It was not surprising, for this was the noise of many voices, each of which tried to outshout its neighbors, so that only it could be heard. Now all was quiet, as if each of the internal voices concentrated and calmly prepared to wait its turn.

With whom to begin? Who had the right to self-expression first? The "Master" had the cloudiest notions concerning this. He decided to let each talk one after the other, stand before him with

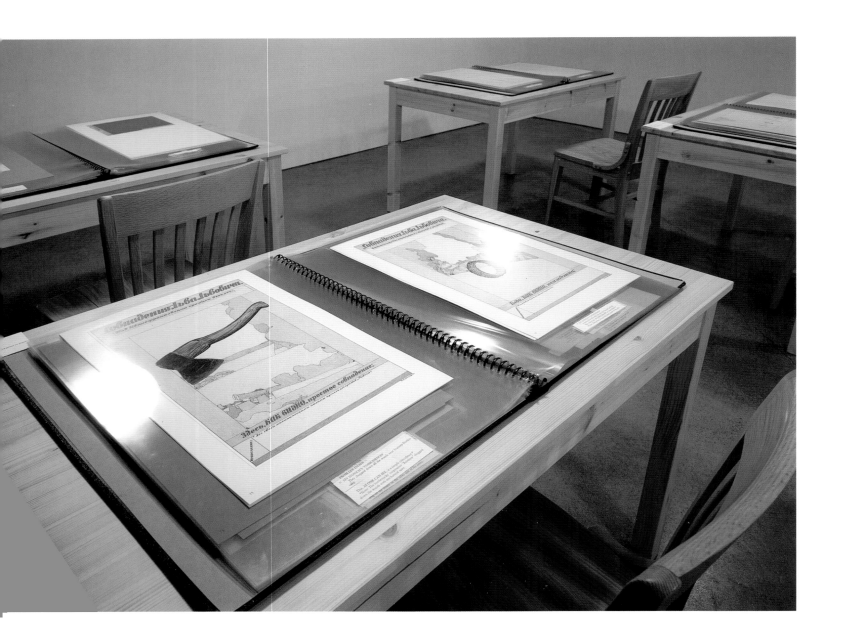

10 Characters album (detail)

his account of the world, and then it would be possible to compare, choose, and determine who is more important, more significant. . .

He began to work. It ended up taking the shape of 10 albums with the corresponding title *10 Characters*. Here is how he describes this genre of "albums" which had suddenly appeared before him. "Albums" are comprised of dense white or gray sheets of cardboard, always of the same dimension (72 1/2 x 35 cm), on which are pasted drawings, clippings, documents, texts, and different sorts of things drawn by the author or already printed.

These sheets (the quantity of sheets varies from 35 to 100) are housed in books, measuring 75 x 38 x 15 cm, which are placed on music stands in a vertical position. Viewers sit before an open book on the stand (one of them turns the pages one by one, from left to right), looks at the drawings, and reads the text.

As a genre, the "albums" are somewhere between several types of art and take from each of them:

From literature (primarily Russian)—narration, subject, heroes, but mainly, the direct inclusion of large amounts of texts, either found or written by the author.

From fine arts—the possibility of a separate sheet of an album to exist as an independent entity and, accordingly, to draw attention to itself, be an object of contemplation, and possess a corresponding compositional structure. Therefore the text which is contained on a sheet of an "album" must be handwritten, thereby maintaining its status as fine art.

From cinematography—the uninterrupted flow of drawings/"stills," of uniform size within the confines of an album, before the immobile, seated viewer.

Most of all, though, the "albums" are like a type of "domestic theater," not contemporary theater where the action takes place in darkness in order to bind and hold more strongly the viewer's attention and swallow him up with what is happening on stage, but more like old theater conducted on a town square in broad daylight where the viewer is unconstricted from the examination and simultaneously the evaluation of the action.

The main feature of the "albums" is that the viewer himself may turn the pages. Besides the physical contact with the page and the possibility to dispose of one's time as one pleases while looking, there is a special effect one gets from turning the pages which makes the "albums" like temporal types of art. A special experience of time occurs from the expectation of things to come like plot, denouement, finale, repetition, rhythm, etc. This genre, from the moment of its origin, reveals all its new possibilities and peculiarities.

Who, though, did these "personages" turn out to be, when one after another they appeared in the world and were able to express themselves fully? Whom do they personify? From the very beginning it's not difficult to guess. They personify the most diverse ideas. Each idea develops to its limit, to its complete manifestation within this personage, then becomes extinguished. Here they are, the names of the 10 albums describing the 10 characters:

Sitting-in-the-Closet Primakov

The Joker Gorokhov

Generous Barmin

Agonizing Surikov

Anna Petrovna Has a Dream

The Flying Komarov

Mathematical Gorski

The Decorator Maligin

Released Gavrilov

The Looking-out-the-Window Arkhipov

Ilya Kabakov

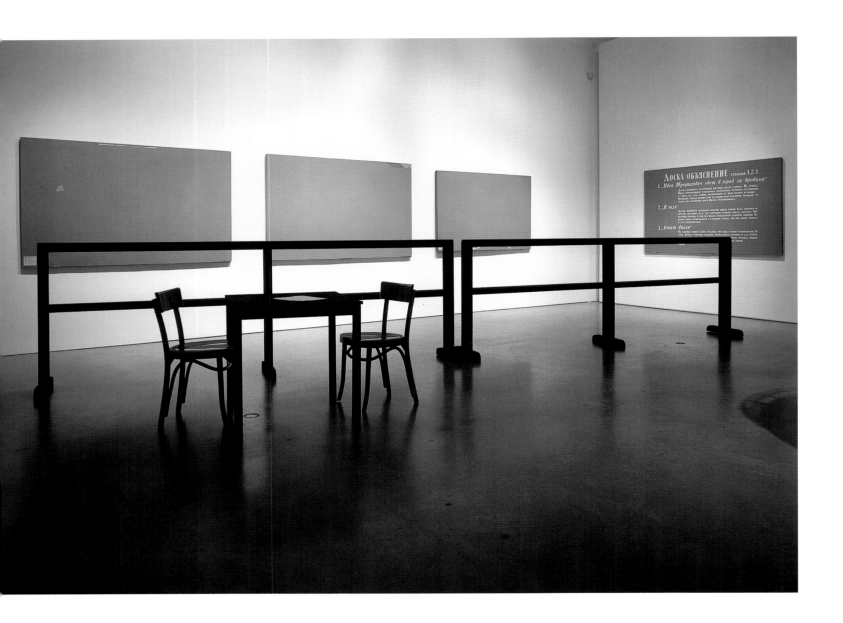

The Russian Series, 1969
Installation view

The Russian Series

Three paintings in this series were completed in 1969 (*In the Corner*, *Ivan Tromfimovich Goes to Town to Collect Firewood*, *They Lie Below*).

Like many paintings of that time, the focus of attention in them is held by their monochrome surface. This surface is pure white, as in the seven big "white" pictures, or is dark-brown as in this series. In both series, the surface is to be perceived in two different ways: as the surface itself, and as the infinite far space like in any ordinary picture. According to this double perception or vision, the disposition of the tiny elements in these paintings correspondingly changes. At one moment they are on the surface, at another—in the infinite depth.

The words "infinitely" and "endless" crop up all the time. This series is named "Russian" because of the idea of our infinite, boundless, vast surface, which is beyond our comprehension, is experienced by all of us. It is apparent here or, as apparent is expressed in our canine language, "is functioning" or "is working." In the given series that endlessness is represented in two different ways: in a graphic, perhaps scientific one like a topography (a scheme of a boundless area) and in a quite visual one, as more emptiness, where next to nothing is to be found. As "topographical" or "science-geographical" objects, these paintings (two of them) are marked with conditional signs explaining what is meant on the scheme (see left-hand bottom corner).

Here, perhaps, a small digression is needed. During my visit to Czechoslovakia all I saw impressed me greatly: houses together

with neatly laid pavement, flowering gardens, clean roads and cultivated land that meets the horizon. With us, it's different: right behind the house starts the endless, vast ocean of nothing, an emptiness familiar with neither man's labor nor with man himself. It is ready at any moment to overflow his miserable being and to submerge him and his creations into its eyeless and shameless abyss.

Returning to our "topography": in the given paintings one could notice the ratio of the indicated objects to the whole surface. Suppose in Europe the ratio of towns, constructions, etc., to the surface forms 1:1, and compared with our country it is 1:1,000 in the roughest approximation, of course. In my pictures I wanted to show namely these "topographical" ratios.

When we turn to the effect of emptiness which comes from the very surface evenly covered with paint, the tiny objects—the circles, the nail, the belt and the squares of the condition—all signs —all are hardly seen on the background of this emptiness. They disappear, they sink in it, they are just about to fall down and crumble.

For many years, I explained my ideas at length to the visitors of my studio until a thought struck me: to write them separately on a large board and to put it next to the exhibited paintings. It came out thrifty and somehow gayer. To my great surprise this explanation suddenly appeared as a picture of the series making the same impression as the paintings did—preposterous and at the same time ridiculous and miserable.

I'd like to say some words about the main character of this whole series—the color. I searched for it creatively for a long time, and it appeared to be a house paint in widespread use, the one we use for painting roofs, passages and floors (that's why it is called floor paint). At one time it was sold in every hardware store. This color seems to have its own "ontological" (deep) meaning. The color of our country, like the whole of our humdrum existence, is fancied to be gray by me. The color of our state power is red. If we mix the first with the second, we'll get the very color with which I overlaid my pictures.

Ivan Tromfimovich Goes to Town to Collect Firewood, 1969, 125 x 197 cm, Masonite, enamel.
The board is overlaid with the paint of sandy color, that of soil. Ivan Tromfimovich is represented by a small black lorry on the stand. The town, where the firewood is to be found, is situated on the right and higher than he. The name of the town is unknown, as well as the names of the towns and the lake on both sides of Ivan Tromfimovich's path.

In the Corner, 1969, 125 x 197 cm, Masonite, enamel.
The board is overlaid with the paint of sandy color, that of soil. If you watch the empty center, something "light-blue" starts to twin-kle in the corner. By shifting the gaze to the corner, small houses that are lit by the sun are seen. But the gaze reverts to the center of the stand as it is hard to look into the corner for a long time.

They Lie Below, 1969, 110 x 172 cm, Masonite, enamel.
The table in the left-hand bottom corner what had been depicted here: the collective farm "Successors" (kolkhoz "Smena"), the bor-ders of the crops, the collective-farm's chief, etc. Those are gone now. A belt, a nail, a samovar and a vase have fallen and remained lying at the bottom edge. The board is overlaid with the paint of sandy color, that of soil.

Ilya Kabakov

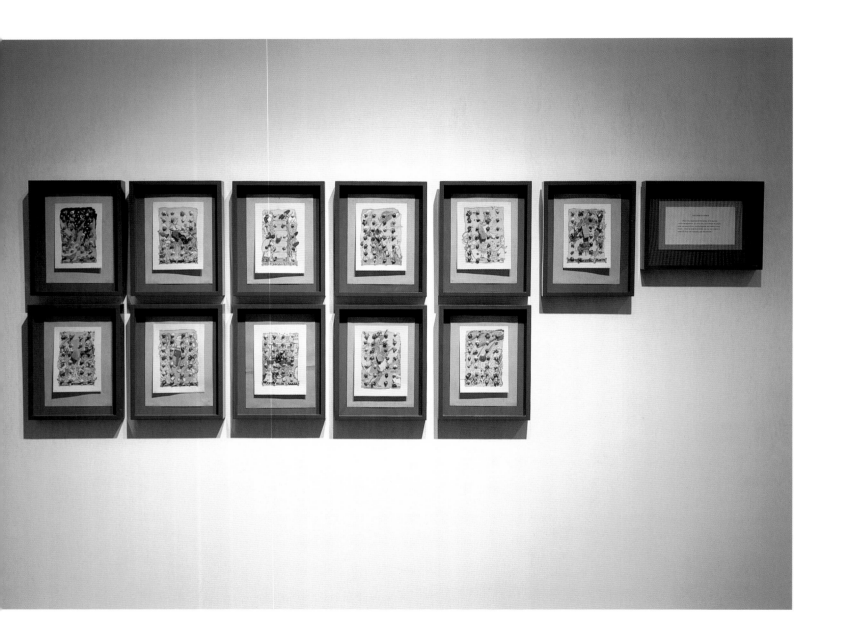

Children's Corner, 1980
Installation view

Children's Corner

Эй,
Спасайтесь поскорей—
Убежал из кухни Клей!
Никого он не жалеет:
Всех,
Кого ни встретит,
Клеит!
Склеил банки и бутылки,
Ложки,
Плошки,
Чашки,
Вилки,
Склеил вешалку и шляпу,
Склеил лампу и пальто,
К стулу он
Приклеил папу—
Не отклеить ни за что!
Склеил книжки и игрушки,
Одеяла и подушки,
Склеил пол и потолок—
И пустился
Наутёк.

Он бежит—и клеит, клеит...
Ну,
А клеить он умеет!

Не успев закончить драки,
Кот
Приклеился к собаке,
А к трамваю
В тот же миг
Прилепился грузовик!
Побежал что было духу
К ним на помощь постовой—
Постового, словно муху,
Клей приклеил
К мостовой!

Что же делать?
Всё пропало!
Люди, вещи, звери, птицы—
Все слепились как попало
И не могут
Разлепиться!

Гаснут в городе огни—
Тоже склеились они...
И глаза
Слипаться стали,
Чтобы все
Скорее
Спали!

The Glue Escapes, 1981–88

The Glue Escapes

Hey,
Run for your lives!
He's escaped from the kitchen.
Who?
Glue!
Everyone he meets
He glues!
Cutlery,
Crockery,
Stockings
And shoes.
Anything,
Everything,
He doesn't care—
He's even glued Papa
Right to the chair!
He glues toys onto books
And ceiling to floor,
And quick as a flash
He's dashed out the door.

He runs and he glues.
He sure knows how.
That's no news!

Even before their fight is over,
He's managed to glue
Tabby to Rover.
And in only a second
A shiny red truck
Finds itself stuck.
To the rescue a militiaman
Glue glues to a span!

What can be done?
Everything's lost!
People, things, beasts and birds—
Everything that Glue's path
Has crossed.
And they won't come unstuck,
No matter the cost!

The city is dark,
Where once it was bright.
Even the lamps now are
Glued out of light.
And eyes
Are shutting tight. . .
Soon all will be sleeping
Soundly tonight.

Translation of text in painting

This painting hangs here for a good reason. The exhibition is dedicated to light and the painting addresses the question of light. It is concerned with fulfillment, with saturation, with the light that pervades a work of art, that comes from within, and cannot be explained.

In Moscow at the beginning of the 1970s there arose a particular interest in the knowledge of things mystic and beyond reason. At that time a singular, spiritual atmosphere developed in Moscow. Influenced by the ideas then prevalent, the white surface of a painting was viewed by the artist as a symbol of emptiness, of nothingness, of death.

Equally, it could be considered as a screen from whose depths is projected a quiet, steady, benevolent light. For the public, the painting would then become a test piece, a kind of shibboleth. If the viewers could adopt a noble, mystical attitude, then they would be able to accept the radiance streaming forth from the painting; they would be able to stand in that radiant light. But if not, the viewer simply saw a plain white, badly constructed board, covered with white paint. And on its surface, poorly executed visual images. . .

Text in installation

нам и тихий, серый, холодный осенний день. Лошадь была уже запряжена, а Николай Петрович все медлил и никак не мог выйти. Поездка его не пугала, к новому пути он был совершенно равнодушен и не думал ни о холодной ночи, ни о грязи, ни о тряске и других обычных неудобствах.

— Ну что, поехали? — голос его попутчика, местного агронома, тоже Николая, звучал слегка хрипловато после холодной ночи. Да и сам Николай Петрович тоже чувствовал себя не совсем хорошо.

"Уже холода наступают, а я из дома выехал в одной рубашке и пиджаке, хорошо, что плащ взял на всякий случай, — подумал он. — Черт бы побрал эту погоду, никогда не знаешь, какой будет, да и вообще, видно, с летом придется распрощаться."

— Да, поехали, — сказал он и со вздохом поднялся со скамьи. Дверь со скрипом отворилась и он, пропуская вперед агронома, увидел за его спиной уже порозовевшее небо, двор, окраину деревни, спускающуюся вниз по косогору дорогу и такой знакомый и уже прискучивший ему за все эти годы вид. В телеге, смешно выделяясь среди остального, лежал старенький холодильник, который хозяин их ночлега, пользуясь случаем, просил Николая Петровича подбросить в соседнюю деревню к свояку.

Николай Петрович работал здесь уже давно, сменил много профессий, и сейчас, уже в должности старшего инспектора лесхознадзора, ехал по вызову в Усолье-Верхнее, где, по звонку района, "необходимо было его срочное присутствие" и где ждали его уже третий день, но куда из-за плохой дороги и поломки телеги он никак не мог попасть.

"В эти края бы да дорогу приличную! Хотя бы такую, как между Выигородом и Халупиным, — с привычной досадой подумал он. — Цены бы этим краям не было. Эх, да что говорить," — он даже поежился, вспомнив про Желудевую падь, между Березовым и Луговиным, которую им предстоит еще сегодня проехать и в которой увязали все без исключения телеги, лошади и даже машины, а в прошлом месяце так засел трехосный самосвал, что его с трудом вытащили два трактора, после того, как он простоял там целую неделю.

"А после прошедших в эти дни дождей, что там теперь," — с тоской подумал Николай Петрович, но тут же решил ни о чем таком не думать, а, по обычной своей манере, вспомнить что-нибудь приятное. А оно было и совсем недавно.

Приятное и даже радостное, было вот что: дочь Николая Петровича, Маруся, поехавшая в Красноярск, выдержала экзамен и поступила в сельскохозяйственный институт. А сколько хлопот было с этой Марусей! "Мой характер," — с удовольствием подумал Николай Петрович, вспомнив, сколько неприятностей всем им всегда доставлял "упрямый" Марусин характер. Стоит только вспомнить, каких споров, слез и уговоров стоило всей семье ее решение переехать в Красноярск и держать экзамен в "сельскохозяйственный". "Что тебе, работы мало здесь, в районе?" — кричали на нее мать и сестра. "Где же ты там жить то будешь, ведь ни одной родной души не сыщешь!" вторила им бабушка. Николай Петрович лишь ог-

Nikolai Petrovich/The Untalented
Artist Displays His Work for All to See,
1981–1988

Nikolai Petrovich/The Untalented Artist Displays His Work for All to See

for us and a quiet, gray, cold autumn day. The horse was harnessed, but Nikolai Petrovich kept stalling and could not bring himself to go out for anything. The trip did not frighten him. In fact, he was totally indifferent to the new journey, and he was not thinking about the cold night, the mud, the bumpiness, or any of the other usual discomforts.

"So, are we going?" asked his travelling companion, a local agronomist, also called Nikolai, in a slightly hoarse voice after the cold night. Nikolai Petrovich didn't feel all that well either. "It's getting cold already, and I left the house in only a shirt and jacket. Good thing I brought a raincoat, just in case. Damn this weather!" he thought. "You never know what it's going to be like. Well, I guess it's time to say goodbye to summer."

"Yeah, let's go," he said and with a sigh stood up from the bench. The door opened with a squeak and, letting the agronomist out first, he saw the already pinkening sky, courtyard, village outskirts, the road winding down the mountain and the view so familiar and already tedious to him after all these years. In the wagon, looking silly among the other things, lay an old refrigerator, which the landlord of their lodgings, taking advantage of the opportunity, asked Nikolai Petrovich to deliver to his brother-in-law's house in the next village.

Nikolai Petrovich had worked here for a long time, changing his profession often, and now, as a senior forestry inspector, had been called to Usolye-Verkhnee where "his presence was needed immediately" and where they had been waiting for him three days already. Because of the bad road and the wagon breaking down, though, he had been unable to get there.

"If there were only a decent road in these regions! At least like the one between Vyshgorod and Khalupin," he thought with his usual annoyance. "Then they would be perfect. Ah, why talk about it?" He even squirmed a little as he remembered the Zheludovsky Ravine between Beryozov and Lugovinov which they still had to cross today and in which all wagons, horses, and even vehicles, without exception, bogged down. Last month a tri-axled dumptruck became so stuck that even two tractors had difficulty dragging it out after it had sat there for a whole week.

"After the rains these past few days, what will it be like now?" thought Nikolai Petrovich melancholically, but right there he resolved not to think about such a thing, and instead, in his usual manner, think about something pleasant. And that something pleasant had happened not all that long ago.

Pleasant, and even joyful, was the following: Nikolai Petrovich's daughter, Marusya, who went to Kranoyarsk, passed her examination and entered the agricultural institute. How many problems there had been with this Marusya! "She has my character," mused Nikolai Petrovich with pleasure, recalling the many unpleasantries Marusya's "stubborn" nature had always brought them. He had only to remember the many arguments, tears and persuasions the whole family had been through with her decision to move to Krasnoyarsk and take the examination for the "aggie" institute. "What's the matter, there's not enough work for you here in our area?" her sister and mother had yelled at her. "Where will you live? You won't be among your own kind there!" echoed her grandmother. Nikolai Petrovich only. . .

Translation of text in painting

37

утро Главный матч сезона. Центральный стадион „Динамо". Москва. *нашей*

Проектное бюро ЦНии ФГн., Омск.

Родины!

Солнечное утро на бульваре. Г. Улан-Удэ.

На практических занятиях в ФЗУ. г. Калининград.

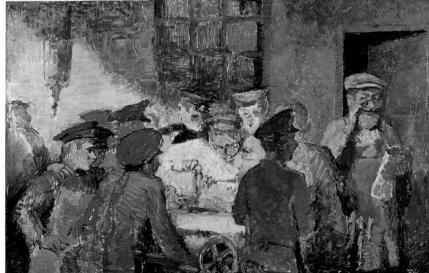

The Untalented Artist, Hello the Morning of the Motherland, 1981–88 38

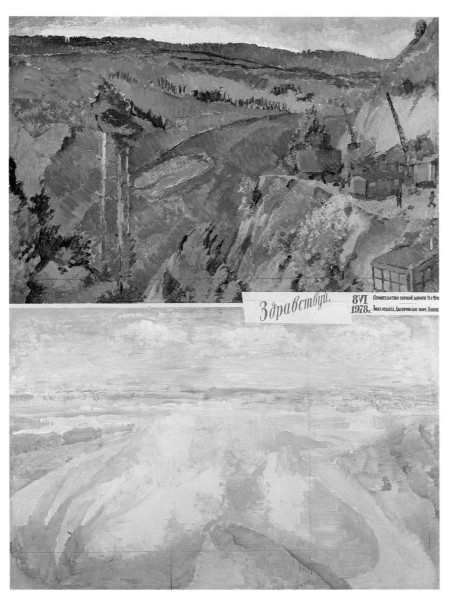

The Untalented Artist, Hello the Morning of the Motherland

This artist works at home, making these paintings of his in the "stand" genre—quickly and garishly painting images which are always in time for some holidays, events or decrees, corresponding to some solemn occasion. Most of these "paintings" are taken down right after the event, but it happens sometimes that they remain on the streets and in the squares for a long time, and belong to, shall we say, visual agitation, and as such they are exposed to the vicissitudes of all types of weather: they get soaked when it rains, damp, crack, and after a while, depending on their condition, they are touched up, repaired or replaced by new ones.

This type of "stand" which our artist makes belongs to the period of the end of the 1950s-beginning of the 1960s in our country, and by now this form of visual agitation has taken on different forms and sizes.

It must be said at the outset that these "painting-stands" were made not by one, but by at least two artists, two participated in the conception and actual realization of these "works." The first of these is the "boss," who ordered the "stand," who proclaimed its theme and idea. This might be the second or third secretary of the party executive committee, the one responsible for "propaganda." Before the approaching holidays he commissioned our artist to do this work "with real materials." Before this the artist had already done all sorts of routine work for the committee: writing slogans, posters, announcements—any work involving lettering and images.

The second author is that very artist who calls himself "untal-ented" aloud to others (although in fact he himself doesn't think this

is so). He is far from young, he is already over 50, and he lived a rather complicated "artistic" life before settling as an artist decorator at the executive committee, for which perhaps he was promised and eventually received a small room in a communal apartment where he lives, receives guests, and carries out his work all at the same time. According to his stories, he graduated from some kind of "courses" when he was young, and had an "elementary art education," but then life threw him around, pushed him, "swallowed him up" and there was no longer the time or energy to become a "real artist". . .

But the "talents of his youth" are still alive and come to the fore in this or that work ordered which are at times executed with skill and even inspiration.

In essence, no one has a need for these "stand-paintings" which we are discussing, just like the two people who are directly connected with them don't have a need for them: neither the young "boss-client" not the artist-producer. The addressee of these works is absolutely ANONYMOUS. Both want to be rid of these "works" as soon as possible, as one wants to be rid of an importunate and tiring fly which refuses to be chased away; and both are governed by a feeling not only of boredom, but also of fear, but if it were possible to say how, in a different sense for each of them. Upon viewing each finished "work," the "boss" ponders whether he'll catch hell from his direct superior (perhaps from the chairman of the committee) when his superior sees this stand in the appropriate place in the square near the committee during the holiday; and trying to guess at the result, he tries to decide to himself whether to give his approval or not to the finished, but obvious hack-work, to make the artist add something or not to give a damn, having decided that "it'll do as is."

On the other hand, the artist himself, afraid not so much of his boss as afraid that he won't "close" the order, assures him that he has done his best and that the result is simply magnificent. A long, agonizing struggle begins between them, in which the boss, himself thinking about future retribution, will plead, threaten and invoke the artist's skill so that he would somehow improve it, add to it, touch up the highly questionable work, and the artist in his turn, assures him that he has done everything possible, that he can't make it any better than it is, and that they should "put it in the shade, under a tree, and then it'll do just fine, after all, it's only for two days. . ."

However, we must be fair to the artist, who, feeling the scale and significance of the order, ambitiously gives free rein to his intuition, visual memory, and to his "elementary art education." Repudiating pathetic repetitions—even though one might expect from him entirely standard ideological production which had been turned out many times before—he makes certain elements and images "from himself," just like he imagined them. And this often lets him down—many fragments of the stand he executes carelessly, thinking that that's how the "great masters" work, and others he leaves out, not suspecting that they even existed. But some of them turn out quite well (like the "game at the stadium" and a few others).

What results is a dreadful mix of obvious hack-work, simple lack of skill, and bright flashes here and there of artistic premonitions and "illuminations."

But as often is the case, a child who is wanted by no one, not his parents, not uncles, not aunts—turns out to be entirely healthy, capable and joyful. . . The rejoicing and the sun somehow break through and exist in the work which is produced in this way, despite, and maybe thanks to the fact that both parents didn't apply to it "all their talent," "responsibility," and "their entire hearts and souls."

Ilya Kabakov

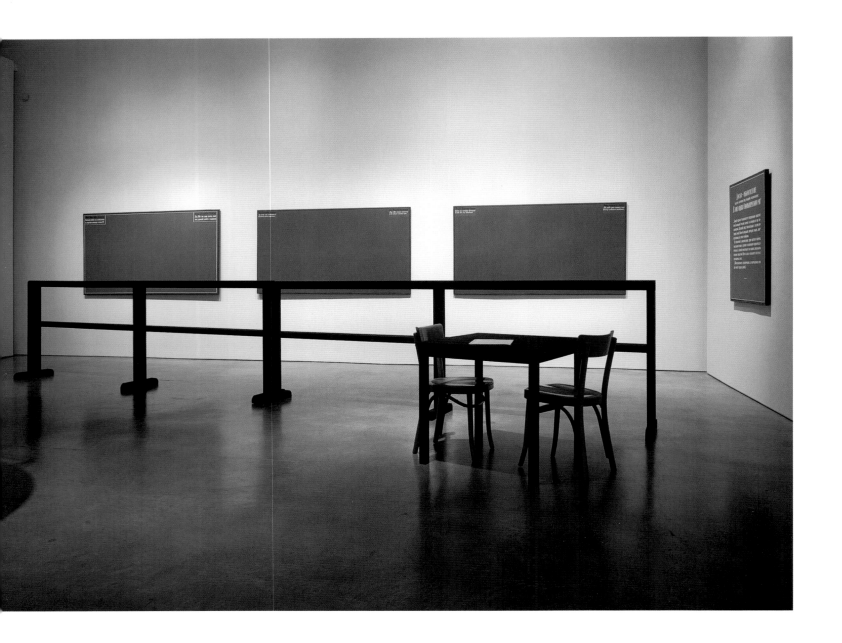

Three Green Paintings, 1983–88
Installation view

42

Three Green Paintings

The composition of this installation is similar to the installation *Three Russian Paintings*, where we also have three paintings and a wall label hanging next to the paintings, barriers and the table with the commentaries.

The content also has its parallels: in both series the main character is color, in both—the main symptom is—the complete emptiness of the surface, the minimal amount of all elements: in *Russian Series* they are scattered on the surface, in *Green Series* they are in the right and left corners.

The most important thing for the understanding in both cases is the presence of the commentaries and the texts on the wall labels.

A few words about the "genre" of both installations: The "genre" of the functional, technical stands, hanging in the hall or auditorium or medical or technical institution or in a factory office is one of those unavoidable decorations to which nobody ever pays attention.

They demonstrate unimaginable boredom and sadness. Both installations, actually, have to produce this "effect": absolutely "non-esthetic" impression.

We shouldn't mistake the emptiness of the background of those paintings with the elegant and esthetically calculated minimalist's paintings, where emptiness and simplicity are the core of their esthetic.

Let's look at each element of the installation and try to "interpret" this element, because in this interpretation is the main idea.

Color: In both installations for the coloring of the boards are used two colors: brown in *Russian* and green in *Green* series.

Both colors were the most used in the Soviet public interiors: factories, schools, offices, laundries, police stations, restrooms, hallways, etc. The brown was used for the floors and the green for the lower part of the walls, up to one meter high. The reason: in order for them "not to get dirty."

And this "color" was exactly the same as you can see on my "paintings." It was as we call it "wearable," easily concocted and sold "ready to use" in any shop. Painters were using it for the wall, as I think, all around the country, wherever there was a construction or repair in progress. This color was well known in '50s–'60s to any "Soviet" citizen and in a way was symbolic to everyone from their childhood, following him all his life—from the maternity room to the last hospital, from the office or factory where he worked to the stairs in his house.

But in those two colors: "our" brown" and "our" green was a special, we can say a metaphysical meaning.

Both colors, of course, subconsciously for their creators—authors—were representing the two colors of our Russian-Soviet nature: color of earth and color of our green.

They both are sad and boring and "heavy," they both emanate some sadness and hopelessness, because of their endlessness, enormous size, and stillness.

Everything that is built or located or happening on them—we are talking about earth and nature—everything tends to disappear, dissolve and drown, to look unimportant and senseless in their bottomless, overpowering presence.

These feelings were the reason for making both series: brown and green.

And, accordingly, the brown is the theme of the earth, the green—of nature and the subject of the texts in the corners of three paintings also is about this.

Ilya Kabakov

In the vacation zone of Sokolniki Region.
The relaxation zone is a specially selected big piece of land in the suburbs in the so called "Green Zone," with a forest, pond and a river. There are a few of those "Zones" around big cities, according to the number of boroughs.

On the weekends the residents of those boroughs travel there with the children and family members in order to relax, to swim, and, in the winter, to ski, to breath fresh air. Often you can hear the happy conversations and laughter here.

Fresh and relaxed people are returning home after the weekend.

The board explanation in a dry, "official" tone is telling about the people, who "after work are relaxing in the specially created 'Zones' of relation, each one in his own district."

The text on the edges of the paintings is the fragments of the dialogues between people, who are "relaxing" in those "Relaxation Zones."

Olga Sergeevna Sobina: "There is a woman behind me in a blue knitted cardigan. . ."
Egor Stephanovich Melchugov: "I'll bring two more boxes and that's it. There is nothing down here anymore."
Irena Gavrilovna Kosheleva: "Look at her! Why can't you sweep properly?!"
Boris Gavrilovich Gordeev: "Now they will serve. Sit here. Don't go anywhere."
Irena Semenovna Savkina: "Where are you throwing the peels? Put everything on paper!"
Vadim Michailovich Budov: "Well, we must go now, it is getting cold and windy."

But those voices, like the meaning of the phrases, like the characters, which are saying to them, are "living" only in the corners and on the edges of this empty, sad space and are talking, without hearing or understanding each other through all the emptiness. . .

Text in the installation

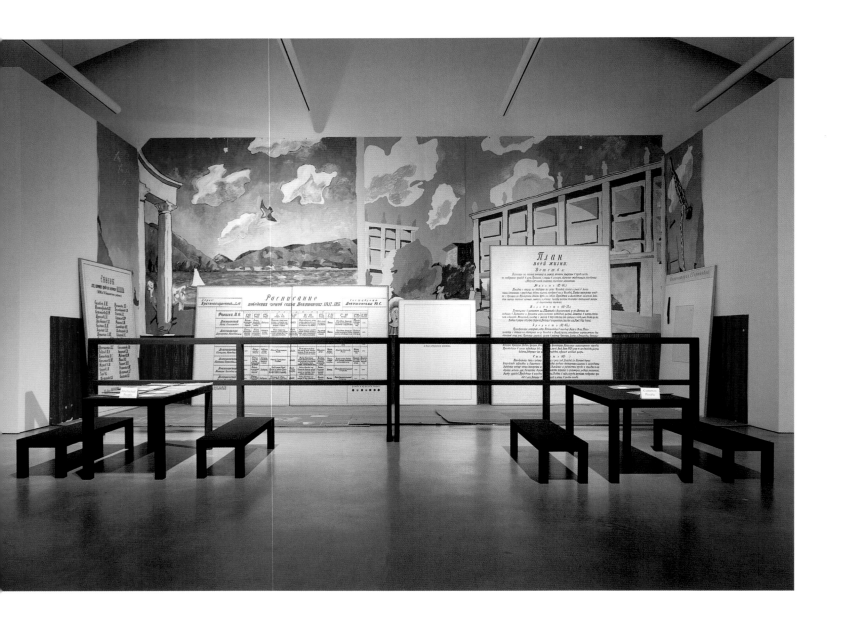

He Went Crazy, Undressed, Ran Away Naked, 1981–89
Installation view

He Went Crazy, Undressed, Ran Away Naked

Foreword

All those paintings have been created not by Kabakov, but by his invented protagonist. Since the invention of the latter, he has drawn over 30 paintings of his own. Presence of a narrator that can't be considered as one with the author is a method widely explored in literature, but in painting its usage may seem somewhat new.

Who is this invented protagonist?

He's anonymous and has no name. It is a mediocre man, one of the many, not too lucky ones. In his youth he enjoyed drawing pictures and even graduated from an Art School. He dreamed of becoming a professional painter, but his fate was to look otherwise: provincial environment, unlucky family life, need for permanent salaries compelled him to part with the painter's career. He paints an enterprise of some small provincial town, receiving offers of decorating local museums, kindergartens and even town feasts. It's a rather common kind of "works of art," exposed on hastily erected wooden boards, and its samples have been produced in our country by thousands all during the sixties. But the works of our author have some peculiarities, that put them a bit aside from the general stream of standard art. Our hero must have been born gifted, the monotony of offers he receives couldn't extinguish in him the spirit of improvisation and of great painter's ambitions. That's why he sometimes creates a masterpiece of the required cartoon, and some of his works

have been created without any requirements only "for his own pleasure."

That is why his works present a rather complicated mixture of postcard banalities and old photos, the embryonic traces of academic education as it was in the fifties and of sudden flashes of creative revelations, that sometimes visit him, bringing enthusiasm into his daily labour. . .

Kharitonov's Story (Apartment-mate)

I didn't know him very well, but then who does know anything very well about someone else living in our "communalka"—so, we run into each other in the kitchen, in the hallway, you say a couple of words to each other and run on. . .it's a dog's life. I didn't know him very well either, I would see him. . . his room was next to the bathroom near the corner of the hall which leads to the kitchen. As far as I remember, he lived alone, a relative would visit him sometimes, a nephew from Vinnits, no, I don't remember exactly where he was from. Why and how did all this happen with him. . . He worked in our ZhEK, that's where he got the room from, but what kind of work did he do? Well, he could do a little bit of everything, he was at everyone's beck and call, so to speak, ready to do anything. . . Then he somehow learned how to sketch and write nicely and he began to write all the announcements, slogans, various schedules, etc. at the ZhEK. In our kitchen, he would write who was supposed to take out the garbage and when,

whose turn it was to use the bath, to clean the hallway. . . He had nice handwriting, his hand was steady, he could write the schedule on the board without a ruler—I saw it myself—he often put those boards in the corner in the kitchen and would write on them, he didn't have room for them in his room. Then he would transfer these boards to the "Red Corner" of the ZhEK, last year he drew all of the agitational murals, slogans, and he gradually began to draw different scenes, landscapes from photographs—he sort of made himself an art studio there. He had his own private key to that "corner."

. . .And so, it was though he moved in there. Of course it was a big place, but dark—there were no windows—and it was a bit damp—it was a big sort of half-basement. But he gradually moved all of his things there and rarely showed up in our apartment. There he would draw large pictures for holidays, with oil paints, and it was though these weren't for the ZhEK at all, but sort of "for himself"—he probably imagined himself to be an artist, and began to think that they would show his works at a real exhibit. This is what probably made him go a little soft in the head, he "lost his marbles" because he imagined himself to be an artist, and maybe it was because life in that basement, in that "Red Corner," where there were portraits, posters, and proclamations all over the place. . . And maybe it was because of some other reason, I don't know.

At the orders of the ZhEK he wrote announcements about who was supposed to do something when: when the courtyard

was to be swept, when we were to go to a subbotnik [a working, unpaid Saturday to clean up the neighborhood—*trans*.], when there would be an excursion. . . And he began, I think, to forget who he was working for and started to write everything as he saw fit: who should go where, what they should do. . . And he started to "lose it" on account of these orders and instructions— he started to make up all kinds of instructions, lists and schedules: who should go where, how they should live. . . I myself saw a lot of these boards standing along the walls in the "Red Corner" when I dropped in there—at that time I already thought that he was a bit out of his mind. But then everything became clear later, when everything happened: all the clothes that he had he hung on these schedules, everything down to his last socks, and ran off in his "birthday suit"—he was seen running down the street completely naked.

A doctor-psychologist from the clinic lives in the room two doors down from the kitchen and he explained how this happened when we were all discussing it in the evening. On his boards where he had written his "own" schedules, the following was written everywhere: "I must complete this by 12 March," or "I will finish this by 15 April." This meant that he felt that he "must" do something, but didn't, and this drove him crazy. It's as though they were a schedule of orders and evidence of their never having been completed. And the doctor says that it is because of this "guilt" that he went crazy—at first he wrote schedules for others, then he started to write them for himself, and this is what

"did him in." And in general, no one ever does anything here. And all those schedules were hanging in our kitchen for nothing: there were only scandals all the time. It didn't matter, everyone did as they pleased, no one read or obeyed these schedules. And in general, in the ZhEK no one ever came out to the "subbotnikis," even if you covered the entire wall with announcements: no one would come or do anything anyway.

I. Kabakov
What is One Supposed to See Here?
1989
In front of us is a portion of the hallway in a large communal apartment in Moscow. Big boards and all kinds of garbage that was left in the room after its tenant left have been dragged out into this hallway. The room will now be taken over by new tenants—his former apartment-mates. Inside the room they are cleaning, washing everything and sweeping out everything that remains. Everything—and there isn't much—has been put in the hallway, and later it will be taken down to the dump, and perhaps the hoarding neighbors will take anything that might come in handy. First of all, they'll take away these big white boards either to build a hen-house at the dacha or to be used later in the apartment as partitions during remodeling.

But it's not at all clear where the little white people who have appeared on the floor in the hall and on the boards came from.

Portions of texts in the installation

Сердито рвет последние листы,
И за сердце хватает холод лютый;
Они стоят,молчат; молчи и ты!
А.А.Фет

Не искушай меня без нужды
Возвратом нежности твоей:
Разочарованному чужды
Все обольщенья прежних дней!
Е.А.Баратынский

Глава VI
СТАРЫЙ ДВОР

...Над страной весенний ветер веет,
С каждым днем все радостнее жить,
И никто на свете не умеет -
Лучше нас смеяться и любить!

Over the Country, the Spring Wind is Blowing, 1983
Installation view

50

Over the Country, the Spring Wind is Blowing

The Red Corner, 1983
Installation view

The Red Corner

Complaint

You are presented here with my complaint with a request to move me out of this apt. and to isolate me from those citizens I have been living with for 15 years already.

No particular attention was paid to my first complaint, but the request of the residents was satisfied and the light was cut off.

My request for relocation results from the fact that in our apartment there are constant scandals and fights every day. These fights are happening not for the first time and I am exclusively considered to be the one to blame. The House Committee, police and even the People's Court have been informed of my hooliganism. No one has bothered to get to the bottom of this, they didn't investigate more thoroughly who is the instigator of these scandals and fights, who is bothering who, and on what basis do they arise. I demand an immediate answer to this complaint, since I am sick of humiliation and these scandals caused by my neighbors that I live with.

It is impossible to live under these conditions that I am living under.

Investigation of the complaint of citizen Rukhmakova who accuses citizen Mylov of opening his letters from the communal apartment mailbox, as well as the complaint by citizen Rakhmakov that the tables in the kitchen are situated incorrectly they are arranged. The matter has been reviewed on site by the members of the House Committee, Glasov, Dmietriev, and Ignatov; that the tables are arranged correctly in the kitchen and Rukhmakov is to be denied his demand, concerning the opening of letters nothing has been proven.
 Signature

Complaint

I request that you review my complaint. I, an invalid of the Patriotic War of the second group, recently received a three-room apartment and I have been living here already about 2 weeks and yet they won't discharge my living registration from there. I did room repairs for them and they didn't like it and they are picking on every little thing and they tell me hire our painters. What am I a millionaire I spent a fortune on those repairs and yet I'm supposed to pay still. I get only 60 rubles and my wife works as a cleaning lady and gets 50 rubles. One daughter is at home with an infant and is supported by her husband. My son-in-law is not registered. They didn't give us living space for him and he is not about to give them money for repairs. After all, he is also feeding two mouths. My other daughter is in the 10th grade and is supported by me. How many years have I lived here and I lived here since 1937. Do you really not feel sorry for my labor. After all, if I had left a dirty room. I didn't think that old people were treated so badly. In other buildings invalids are treated with care and respect, but here it's the opposite, and the engineer of the building is even a Communist. I am also a Communist, and if I was in your place I would never act like you're acting you are getting on the nerves of a sick person. I request that you review my complaint.

1/XI-66 Vlasov

Translations of texts in the installation

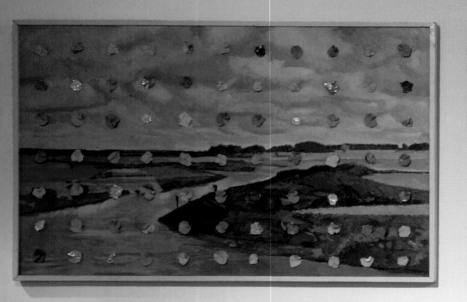
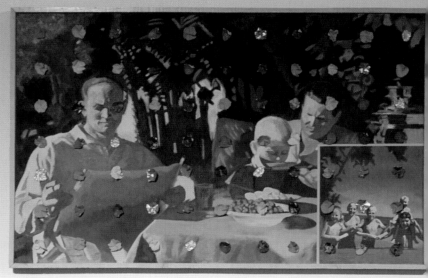
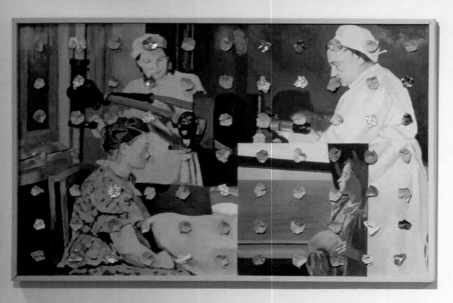
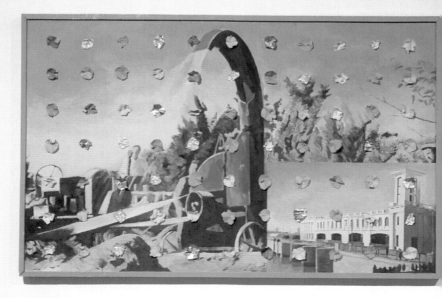

Holidays #8, #10, #7, #6, #4, #5, #9, #2, 1987. Installation View

Holidays

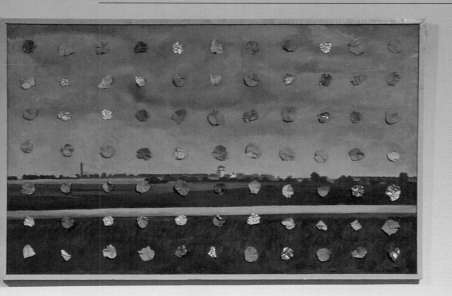

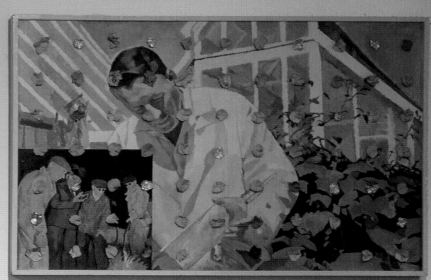

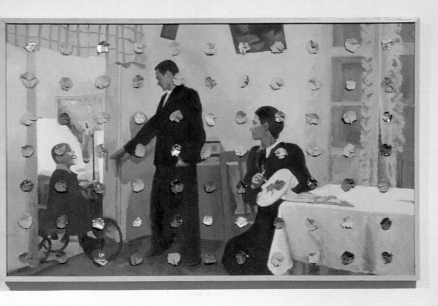

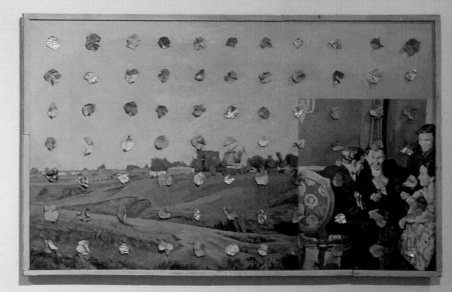

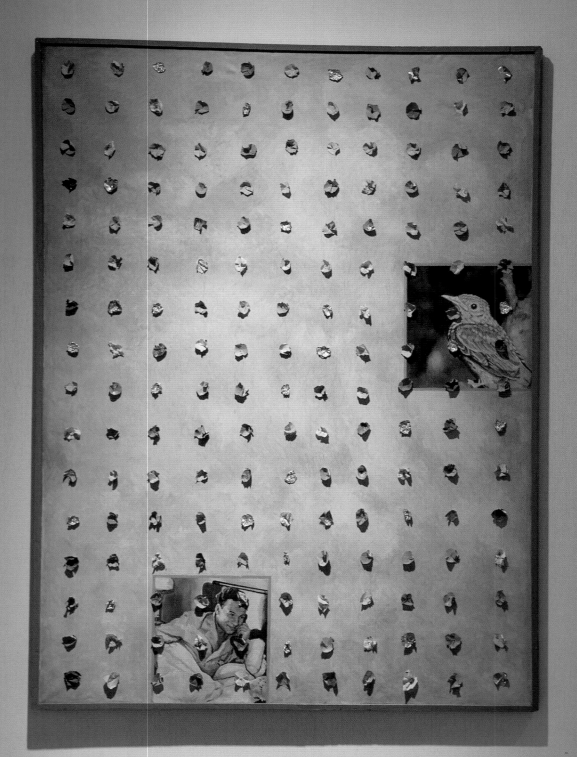

Holidays #11, 1987

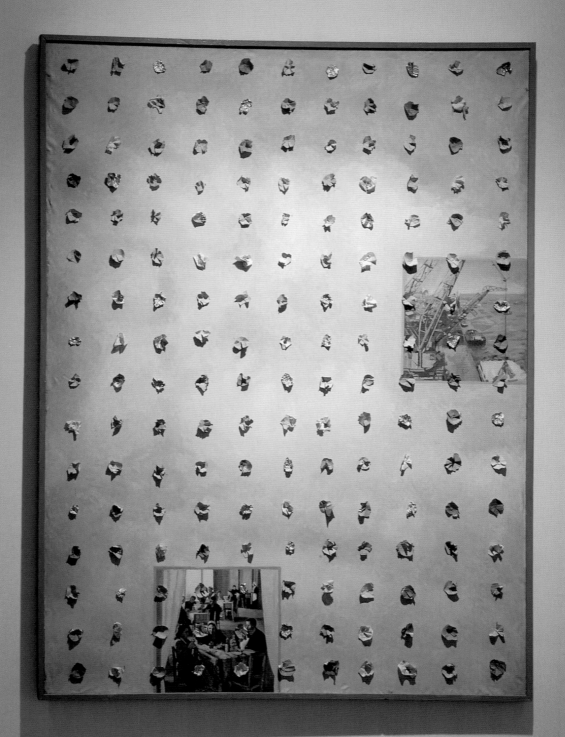

Holidays #12, 1987

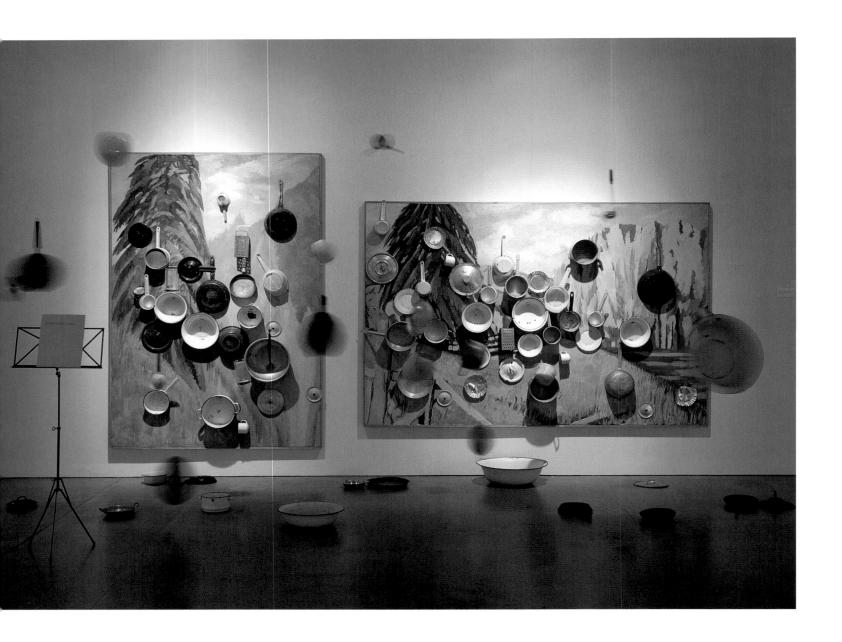

Incident in the Corridor near the Kitchen, 1988
Installation view

Incident in the Corridor near the Kitchen

When Olga Nicolaevna came to the kitchen in the morning she saw in the corridor numerous pots, pans, and plates, which were flying in the air.

Text in the installation

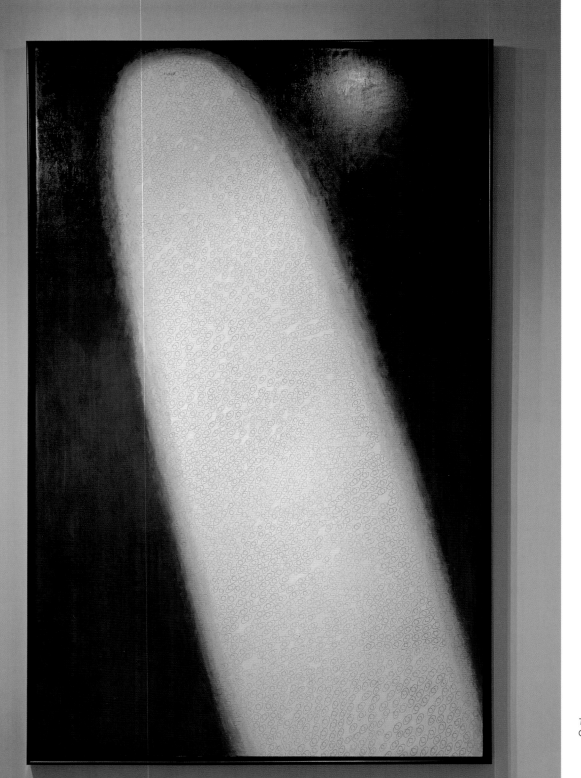

The Three Nights, 1988
One of three paintings in the installation

The Three Nights

It is a large and high dwelling (12 x 8 x 6 m). There are three paintings, one on each of the light-yellow, almost white walls. A vertical painting (368 x 226) hangs on the left, a large horizontal one (224 x 590) is in the center, and on the right of it is also a horizontal one (320 x 808). There is neither a name nor an inscription either on the paintings themselves or near them. It is not clear what they are called or who did them. But the method of *Lasierung* was used in their preparation, so it seems that they could have been made a long time ago. Night is depicted on all three paintings. On the right, vertical painting, the night is separating to both sides, similar to a black curtain. In the opening light space many people walking are visible, but sort of from above, from a bird's-eye view, and so only the shoulders, heads and noses can be seen.

On the second painting, there is a large beetle sitting on a green leaf in the lower left corner, while the entire space of the painting is almost black—night. Children's verses, or rather verses for children, are written in neat handwriting along the entire length of the lower edge, on top of the "night."

On the third painting is depicted a night sky covered with stars, there are household articles (a cup, a plate, a meat grinder) in the light-golden middle of each star, each star has its own object.

There is a partition built from three walls in the center of the room, and the viewer can freely enter it. There is a square hole in each of the walls at eye-level, binoculars through which the viewer may look are placed opposite the hole. On the front part of the partition there is an explanatory text, and the same kind of text next to each hole. It follows from the explanations, that figures of little white people began to appear in different places on each of the three paintings, even before they wound up at the exhibit. But it is impossible to see them on the surface of the painting with the naked eye, they are visible only through the binoculars.

Ilya Kabakov

Detail of painting on p. 60

61

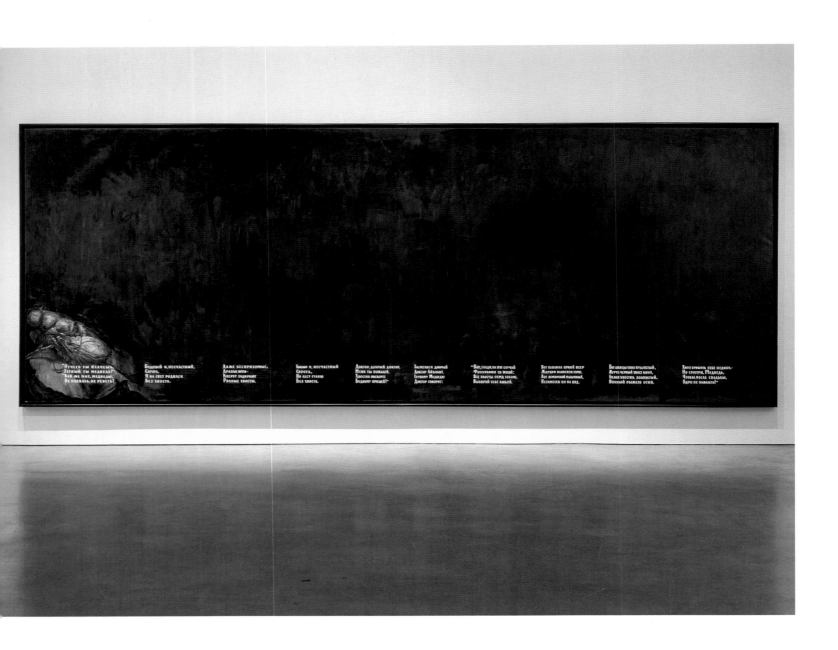

The Three Nights, 1988
One of three paintings in the installation

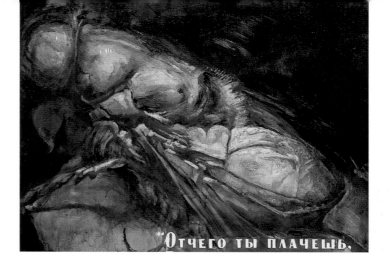

In 1978 in the Voronezh Picture Gallery during an examination of one of the three paintings by the common name *Three Nights* (the paintings arrived in the Museum in 1938, and it has been impossible to establish either the name of the artist or the genuine title of the works, the title *Three Nights* was given conditionally), details were accidentally discovered in its upper part that until that time had not attracted attention to themselves. These were figures of small white people, no larger than one centimeter in size. It was suggested that such creatures might also turn out to be on the other two paintings. In fact, a thorough examination of the paintings *Night No. 2* and *Night No. 3* affirmed this, which was recorded by photograph at that time, in the fall of 1978.

During an examination of the paintings in 1982, the location of the white figures had shifted from their original place by 40 cm. Continual observation of the little figures had been conducted from that time, and their new location is specifically recorded.

2.1.1985

Deputy Director

Voronezh Picture Gallery (Voronov)

Scientific Secretary of the Museum (Ignatiev)

Text in the installation

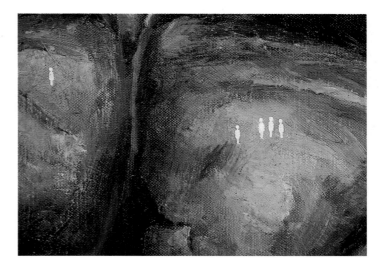

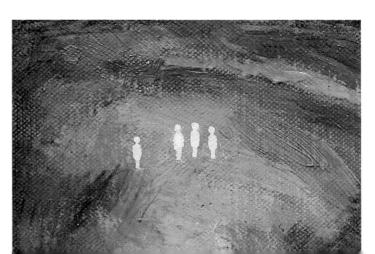

Details of painting on p. 62

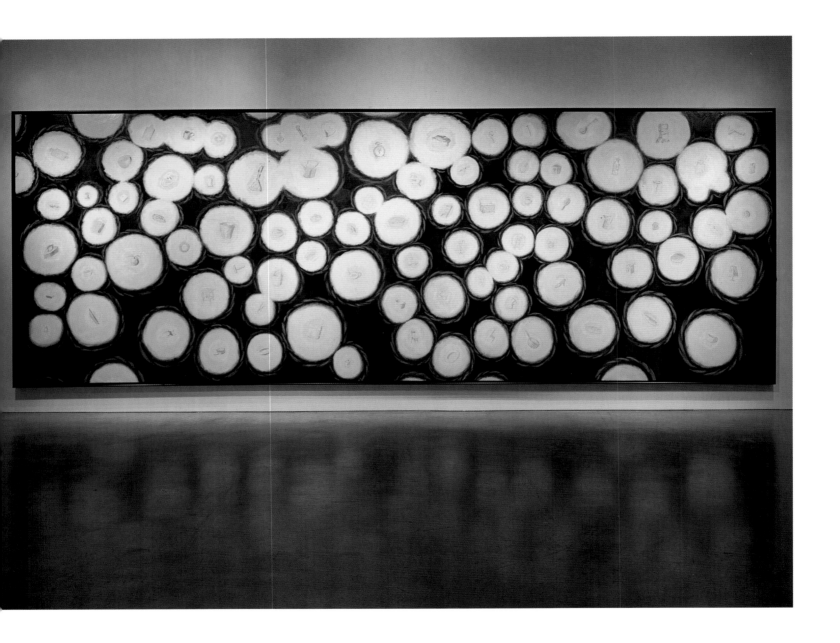

The Three Nights, 1988
One of three paintings in the installation

All three paintings are very well done: they are carefully drawn, the method of *Lasierung* has been applied to them, like genuine paintings of the XIX century. In a word, we have before us "great" painting, entirely worthy of admiration. Herein lies the main characteristic of the installation: the paintings are good in and out of themselves, they do not need anything extraneous. Furthermore, they belong to "visionary" art. But it unexpectedly becomes clear, that "little white people" have appeared on them. A certain mystery is thereby imparted to the paintings. But there is a mystical, strange element in the paintings also, in the fact that it is not clear how *Three Nights* came to be. As a result, two mysterious spaces arise— "there" in the depths of the paintings, and "here" in the space of the viewer. But isn't there some sort of connection between the "visionary" nature of the paintings and the appearance of little white people on the surface?

Text in the installation

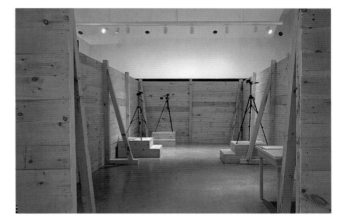

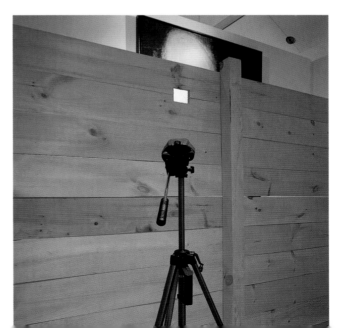

Installation views

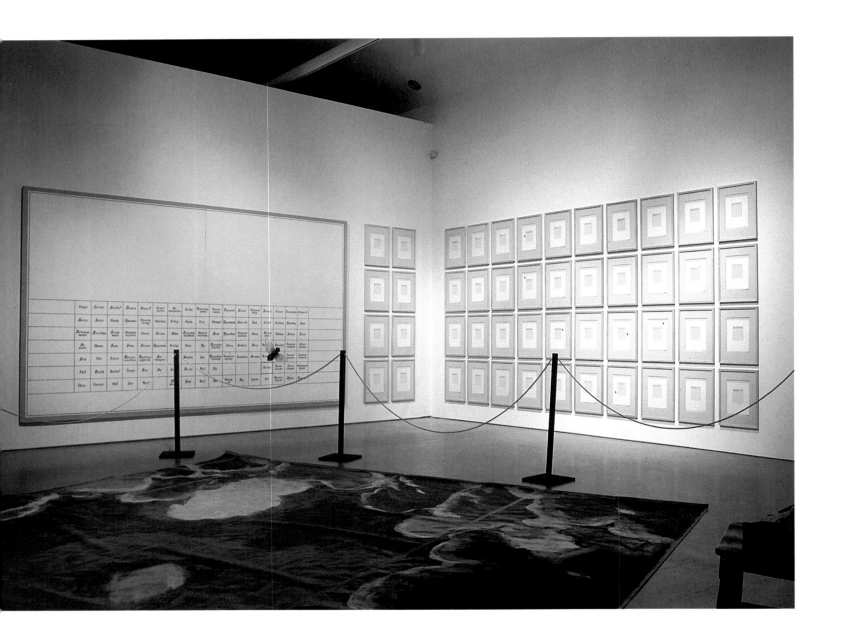

The Fly and the Tabular Poetry, 1989
Installation view

66

The Fly and the Tabular Poetry

Flies, or more precisely, the depiction of flies, has come to play a significant role recently in contemporary poetry, especially in that new, rapidly developing movement which has been given the name "tabular poetry." In it the depiction of the fly plays the role of an extra member, the idea of which lies in the fact that it is absolutely unnecessary, yet there is no possible way to get rid of it. But why then do we have this depiction and its presence at all? But more about this later; first a bit about just what "tabular poetry" is.

As is well-known already, in the beginning of the XX century, in certain trends in contemporary poetry, more and more meaning began to be attributed to its "visualization," i.e. the effect on the reader not only by means of traditional poetic devices, such as rhyme, rhythm, size, etc., but also its visual "image"—a way of outlining the poetic line, the order (or disorder) or the letters, variations in their size. To a certain degree, poems began to turn into something resembling a painting—on the printed page arose a fountain, trees, or a portrait of the poet himself (Apollinaire, Aragon). It was proposed that the reader not only read, but also "contemplate" in this way the given poem, more precisely, to combine in his perception both the former and the latter. He was to become simultaneously both a reader and a viewer of this new "visual-verbal" centaur. "Tabular poetry" belongs to this tradition which has already become quite durable. "Tabular poetry" can be described in the following way: One, or more rarely, two or three words are written into each cell of a table which has been outlined into squares, and which has been called the poetic "field."

The reader is prompted not "to read" but "to look at" the entire "field" all at once, in the same way that is generally done in the contemplation of a drawing or painting. With this method of perception, all of the written words enter our consciousness simultaneously, and create, according to the idea of the creators of "tabular poetry," an intensive and unique poetic image. (It stands to reason that at the same time a line-by-line reading of "tabular poetry" loses its meaning.) But, the reader-viewer will say, how does the depiction of the fly fit in? Isn't it possible to do without it altogether? No, it is not possible, the author of "tabular poetry" will answer, and here's why:

The principle of the "extra member," as discussed above, consists in the fact that by itself this "extra member" is absolutely without meaning, and it is precisely because of this that it stimulates and activates the perception of that in relation to which it turns out to be superfluous. We have already said above that "tabular poetry" depends upon the unified and summary glance of the viewer at the entire table presented to him as a whole. But the practice of examining tables (as with all diagrams, schedules, etc.) is such that they do not permit themselves to be viewed in this capacity, but force one to delve into each cell, into each part of the graph separately.

And this is where the role of the sketched fly manifests itself as the activator of this "whole." In relation to this interference, the fly which has appeared unexpectedly and who knows from where, the "poetic table" begins to function as a complex, but at the same time integral, organism enclosed in a single frame, where each word, which is not at all insignificant, functions "as an equal" in relation to all other words, not being differentiated from them in any way. This represents one of the important conditions for the effect of "tabular poetry."

But why is it the fly that is chosen by the artists to serve as this superfluous member, and why can't another object such as a rabbit or a footstool serve in the same way?

In "tabular poetry" the fly serves this function because, in the first place, it prompts a reference to a situation with which everyone is familiar: the fly, having importunately sat on the book of a page, interferes with reading; and secondly, any other object depicted for this purpose would turn out to be highly significant semantically (that very same rabbit, ball, or footstool), and the reader would involuntarily begin to search for a connection between that object and the words, to see in them a unique illustration, illumination, and this of course, is not desirable.

The fly, in the opinion of one of the inventors of "tabular poetry" B. Utiugov, in this regard turns out to be sufficiently neutral: on the one hand it doesn't serve to point to any special idea or context, and on the other, it activates the text which is lying next to it with a special force, the reason for which it still remains hidden.

Ilya Kabakov

"Flies and 'Tabular Poetry'" is reprinted from *Ilya Kabakov: Das Leben der Fliegen* (Kölnischer Kunstverein and Edition Cantz, 1992) by permission of the author and the Kölnischer Kunstverein.

Morning	Spring	When?	Let's go	How long?	Brushed slightly	Not for nothing	Forgot	To arrive here?	In the morning-It is painful	The ship	The old yard	Evening	Blue	Let's see	Come back!
Roar	Easy	Knock	Pleasant	Evening	Cloud	North	Here	Salt	Again?	Flying over	Orchard	Dinner	Alphabet	Ropes	Part
It's quiet in the evening	Trip	White dust	Old Man	Moan	Spring	Beetle	Dirty jacket	Strong light	No	Coming over	Here	Always here	Sitting	Wind	The flight
Not necessary	Window	Pain	Speech	Spring	Throwing	Dome	Snow	Forest	Sick air	Coming	Soap		Some-times?	So many things?	Here is a beam
Mine	Soup	Channel	The letter came late	Carrots were brought	Every-thing old	Garbage	Always	Ray	Doctor is coming	Strong wind	I don't know	Nonsense		Old Coat	Old shoes
Row	Escape	Where?	Porridge	All	Rice	Fence	Escape	Where?	Noise			Fence	The trains are coming	Here it's painful	Waste my time
Oleg	Glass	Ouch	Onion	Hour?		Here is living	Here	Hour?	Soup	Blue Forest	Greenery	Forest	The far away tree	The wing	Sparrow

Translation of texts in painting

Close the window, for some reason I'm really cold all of a sudden. . .

Such butterflies fly around our garden in the summer!. . .

Oh no, he's very reserved, he just sits there and doesn't say anything. . .

It's so depressing and boring in the evening. . .

You know, I often sit like this and don't know what to do. . .

He started digging around in a heap of papers, pretending that he didn't notice me. . .

We can wait for the rain to stop here. . .

She put a golden band on her head and thinks she looks good in it!. . .

Let's go to the garden and play—I have a certain place there. . .

Close your eyes and go to sleep, it will be better that way. . .

You don't have to do exercises, there's no use in it anyway. . .

No, you can't jump over that line. . .

A little stream, a little stream. . .what little stream is this?

Don't forget to bring me toys when you come back from there! OK?

And yet after that you'll make another criticism!

As usual, my stomach is rumbling today. I don't know what to do. . .

But why do you keep bothering me all the time? Leave me alone!

They've started cutting down the forest again over beyond the river. . .

Oh look, isn't that him sitting there in the window?!

If they had started out doing it right from the beginning, it wouldn't have turned out like this now. . .

Kolya, Kolya, come here quick, look what I brought for you!

The fish was lying on the table for two days, of course it spoiled. . .

It seems her husband served in the artillery institute. . .

Look, quick, what's happened here. . .

Ice cream has gotten expensive again, it's now a ruble twelve. . .

I already told you that before, remember, that intellectualism will ruin art?

You know, my legs are really tired, but there's nowhere to sit here. . .

Something very sad emanates from all of this. . .

The trees are swaying so gloomily, incessantly. . .

And you know where the glass turned up? It was rolling around under the table!

You know yourself, that major events happen in life so rarely, and really significant ones never happen. . .

But old age, that's no time for making new plans. . .

I'm warning you ahead of time, it will be boring there.

Was it really possible to go out to the country, in such cold weather?

I really like that girl.

In the evening there's nothing to do, again. And you don't know what to do to keep busy until bedtime. . .

And there's nowhere for the melancholy to go. I am simply suffocating from it. . .

I don't know at all what happened to him. I heard he is in the clinic for people with nervous disorders. . .

It doesn't matter, that will never, never happen, no matter how much you beg. . .

Remember they used to sing this song at some point, "The bells are ringing in unison"?

I think it smells like fried chicken. . .

He was asked ten times, and finally he responded. . .

If you had worn your felt boots, the ones you bought last year, then it would be a different story. . .

Leonid believes that divine light will appear in the future not in just one person, but in humanity as a whole all at once. . .

Are you really not ashamed to talk to me that way?

Cut the cucumbers and put them on the table—look, the guests have arrived already. . .

We have to get up tomorrow as early as possible and start cleaning right away—everything is all messed up, neglected. . .

If you're so polite and attentive, you could at least have taken out the garbage pail!

Translation of texts in the installation

71

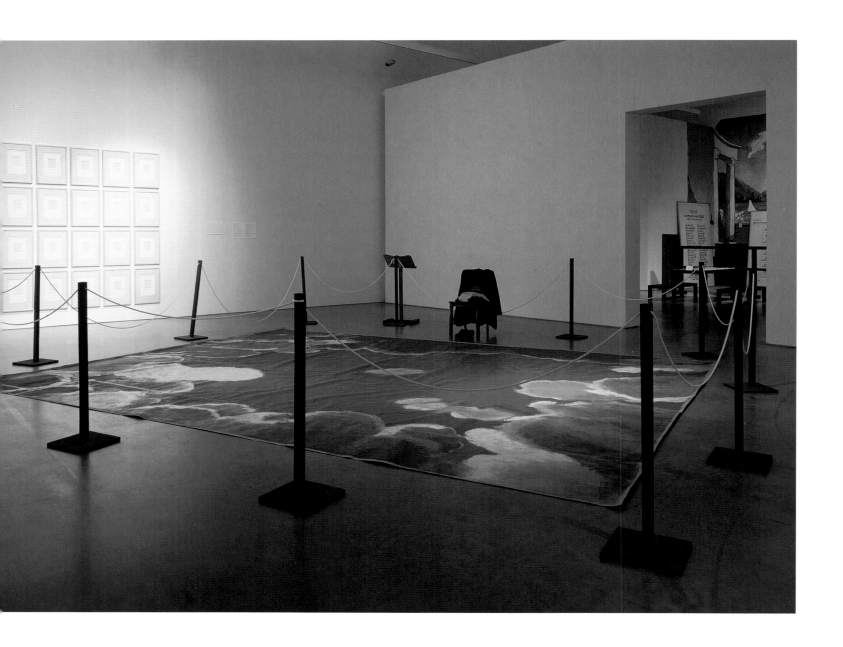

I'll Return by April 12th, 1989
Installation view

I'll Return by April 12th

Description of the Installation

In the exhibition hall, where paintings are hanging along the walls and sculptures are standing on pedestals, there is a large piece of gray wrapping paper (5.5 x 4.5 m) on which a dark blue sky covered with white clouds is painted in oil. It is drawn very approximately, crudely, in such a way merely to give the idea of what we might feel if we were to thrust back our heads and look at the zenith on a sunny day. Hence, the "sky" lying on the floor is before the viewer. Next to this paper sky is an old chair, and a jacket, trousers, a shirt, an undershirt, underwear and socks are folded and hanging neatly on the back of the chair, and under the chair are old boots, in a word, the simple wardrobe of a person who has undressed and. . .

A stand with a short text is on the other side of the "sky," opposite the chair with things.

Ilya Kabakov

Commentary I

The installation was made specifically for the program *Paintings for the Sky* at the Goethe Institute in Osaka. All of the paintings for this program are kites, constructed by artists from all corners of the world. Therefore, I wanted to make something for the program (it is supposed to travel around the world for four years) that was contrary to everything else exhibited, along the lines of "everyone has gone out to play but I stayed home," with all of the complexes of a failure, a person who has been left to sit in the corner.

He has also "gone with everyone" but in his own way. Everyone has flown into the sky, and so has he. But, of course, in his imagination. He has also "dived into the sky" and has disappeared there. Here, as a matter of fact, the well-known expression "he drowned" in the sky comes into play, whereby according to this direct metaphor the sky becomes a swimming pool (the paper, painted sky intensifies the effect of fantasizing). In this case we could recall the well-known anecdote about the patients in an insane asylum who are diving into a pool without water.

Commentary II

. . .How often I would soar above the earth, just like that, without any airplanes, balloons, even without ordinary wings. My sensations in this case didn't suffer from those of other people who found themselves in the same situation. But for me—I recall and sort through all of my flights in my memory—the most wonderful one still remains my first flight that occurred in earliest childhood, when, it seems, I was 8 years old. . .

. . .You make a running start, take two-three quick steps on the ground, and spreading your arms, you begin your journey though the air, having torn away from the earth. At first you fly not very high, only 3–4 meters above the earth, and you can pretty well imagine your speed (around 20 km per hour). And a small brook, almost a little stream shines below you: I fly right up to the edge of the precipice, and at a great distance under me I see an entire city with parks, buildings, cars, and far ahead is a sea in a blue haze. I am flying through cool air, I turn to the side, go down headfirst, I do somersaults like in warm water, I experience an unbelievable feeling of bliss and peace. Simply for the sake of a joke, out of curiosity, I descend toward the buildings surrounded by trees, I peep into the windows, lingering briefly near them. . .

. . .Then I decide to ascend and continue my flight. I lie on my back, my legs and arms are hanging downward, my face is turned upward, my eyes are half-closed, a bright light penetrates through my eyelids. There is a marvelous, extraordinary quietness all around which is only sometimes pierced from below me by the voices of swallows and swifts. I again decide to rise up higher and I do so smoothly and at great speed, the earth is already 5–6 km away from me, it is almost indiscernible in the bluish-rose colored haze.

And here I am already "between heaven and earth," on the border. When I open my eyes slightly there is a pure, bright blueness, a radiant sky, the sea coastline is barely discernable in the bright fog below, a thin white strip of beach. . .

In actual reality I only experienced such a thing twice, and only partially at that. The first time was when I traveled around the Crimea alone, in an area that at the time was still the completely deserted, undeveloped coastline of the Black Sea. And I would spend long days walking along the beach, along the edge separating the sea and land. In a strange oblivion I stopped differentiating where the sky ends and the sea begins, where is up and where is down. The second time I felt the same thing was when I was in Eric Bulatov's studio and I saw for the first time his finished work "I'm going!" which at the time seemed to me to be done with the same feeling that I have tried to talk about briefly here.

Ilya Kabakov

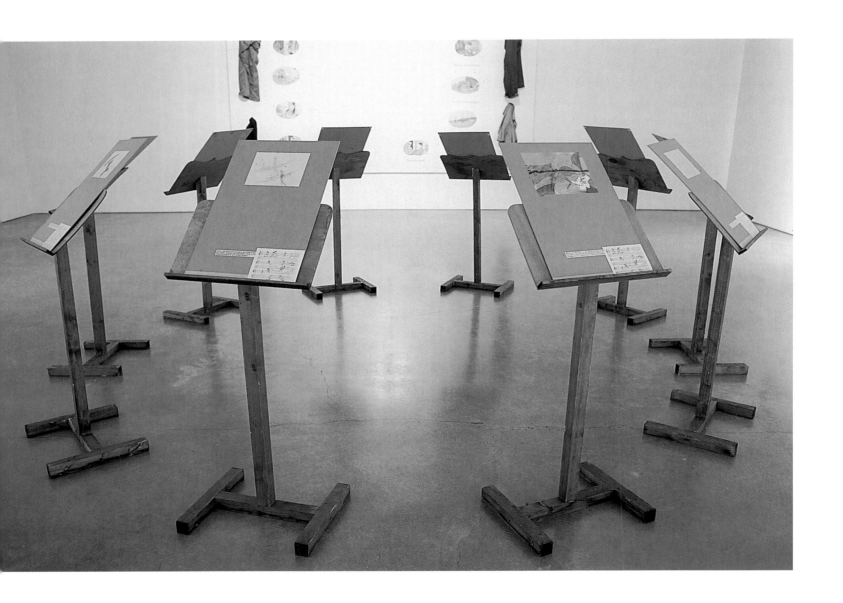

The Concert for a Fly, 1992
Installation view

The Concert for a Fly

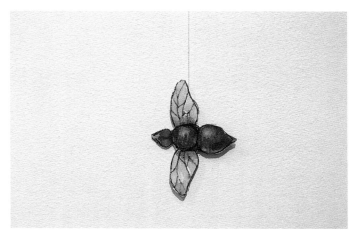

Detail of installation view on p 76

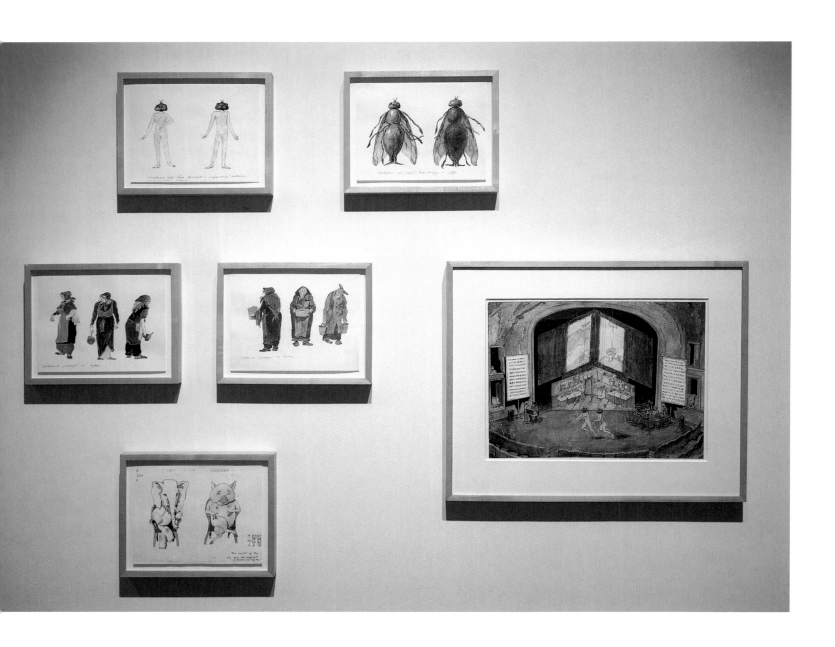

Set and Costume designs from the Brooklyn Academy of Music's
production of *The Flies*, 1992–1995
Installation view

The Flies

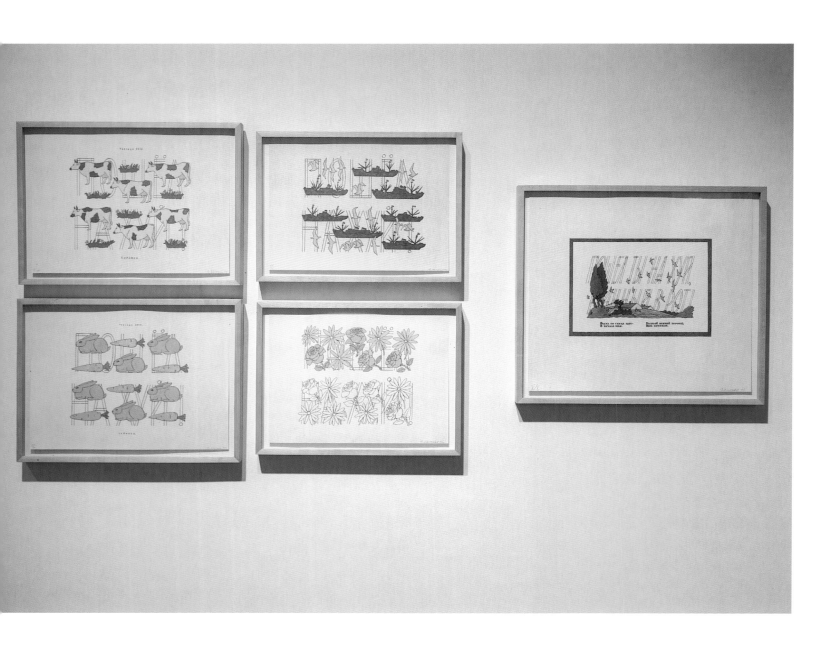

From the *Children's Coloring Book*, 1993–95
Installation view

Children's Coloring Book

On Volodja's birthday his father went to a children's store and bought a coloring book. When Mother looked through the book, she became horrified: behind each of the beautiful images of the rabbits, cows, and flowers, she discovered terrible, disgusting curses. The strangest thing was that those bad words were printed in the same way as the images for coloring. Who came up with such a terrible joke in the children's book?!

In order to find out, the father went to a neighbor, who was working in the militia and who immediately started the investigation.

Text in the installation

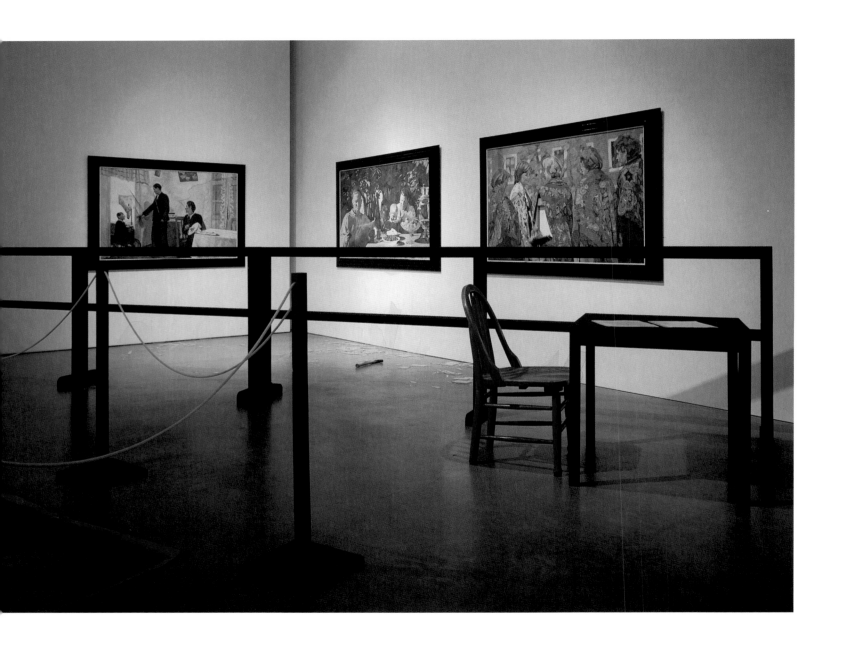

The Artist's Despair, or the Conspiracy of the Untalented, 1994
Installation view

The Artist's Despair, or the Conspiracy of the Untalented

A rather rare incident occurred in our gallery which even now we are unable to explain fully. An exhibit had been in the works for some time already, and after a painstaking selection process it was decided to exhibit these three paintings. The opening went as usual, there were a lot of people invited and everyone, including the artist, was happy and pleasantly excited, so that it was difficult to even imagine what was going to happen later.

Early the next morning the artist asked to be let into the gallery before it opened and he quickly went right to the hall where his paintings were hanging. Suddenly, we heard from upstairs a loud noise of breaking glass and the pounding of something heavy. We rushed upstairs and ran into the artist in the doorway. He was extremely agitated and disheveled, he pushed us out of the way and ran down the stairs.

We were stunned by the spectacle before us. The glass on all three paintings was completely smashed, the entire floor around them was covered in fragments. But the paintings themselves also present- ed a horrible sight. Something heavy and sharp was pounded through each of them, not in just one place, but in many places, and we saw immediately that it would be virtually impossible to restore them.

Suddenly things took an entirely unpredictable turn. . . Among those who had entered the room and who were crowded around the ruined paintings was Jan L., a young but already rather well known critic and art scholar. Seeing that we were about to take the paintings off the wall and sweep the floor, he gestured to us to stop, as though some sudden decision had dawned on him.

"Leave everything as it is, don't touch anything!" With these words he pushed everyone aside. "Don't you see that before you is an astounding installation, completely ready, you don't need to change a thing, just add the missing details!"

With these words he immediately asked someone for a pencil and scraps of paper, and, as though in a burst of inspiration, began to toss them, explaining all the while with the words: "An installation is three-dimensional, but paintings hanging on the wall even along with their frames are two-dimensional. The glass fragments scattered on the floor didn't add much. Something three-dimensional has to be added, voluminous—we will place a long barrier in front of the paintings: it will create a certain spatial effect, and, by the way, it will be a little like a police barrier. And furthermore, we will get what the structuralists called 'making it strange,' we will get a different, more elevated point of view on what is happening, with a different level of consciousness. This is what Derrida would say in such a case: 'The voice, resounding in the context of deconstruction, is inevitably connected with the weight of the word and the intensity of the listening.' But there is still something else: a table and two chairs could be placed in front of the barrier, and a story placed on the table about how all this happened, and we will get one of the most interesting types of installations, combining the visual level and texts, one of the most sophisticated and witty genres of this type of art. Let's recall Foucault: 'Doesn't the entire field of texts taken in its full volume correspond to the point of idea existing in parallel with their meanings?'"

. . .We agreed to this suggestion (although we didn't get the artist's consent, we don't know where to find him even to this day).

We agreed to this suggestion exclusively with the goals of participating in the discussion heating up everywhere today about the installation and its future fate.

A.B., art critic:

"It still has to be proven that this is not just a 'type' of art, but that installation in general is art at all. I seriously doubt this, at least for me the Biennial in Venice where for the most part this 'type of art' was displayed, appeared to me to be a repulsive dump of all kinds of garbage. Thank God, this repulsive dust cloud had already started to dissipate, and soon there won't be even a trace of it left. But it's surprising how some people have enough ambitions to assure others of the coming 'victory' of these dumps of things, the death of painting, etc. 'Malbrook is ready for a campaign' but the painting, as it did, still remains in the center of the art world, which is illustrated by the multitude of first-class exhibits taking place again today where there are only paintings. . ."

O. Kul, psychologist:

"I don't know about the duel between the installation and the painting, but the idea itself is not devoid of wit and a certain depth. In line with my research at the department of psychology at the Polytechnic University, I am very interested in the idea put forth here of transforming the destroyed paintings into an installation. Two very intriguing problems, from the point of view of a psychologist, arise with this.

"I'll begin with the first. Before us is a very curious and characteristic phenomenon: what for one consciousness is death and destruction, for another is creation and a successful discovery! I repeat, what is before us now—and we are witnesses of this—is the most genuine, authentic, 'eureka-like' act, an ideal example of living creativity—not the remaking of something into something else, but the birth of something by the very **act of reinterpretation!**"

K. Zonnhaffen, artist:

"Well, I don't know about 'eureka-like,' and I don't even know what kind of a word that is, but I agree that the mass enthusiasm today by the youth, and not only by the youth, for what is called the 'installation,' exhibits of it everywhere in galleries, museums, can be called—and let its fans and theoreticians of whom there are many get angry—simply a conspiracy of the untalented and nothing more.

"I won't give his last name, we studied together and he never could get good results: not in composition, nor in color, nor in balance of parts—it's not worth delving into professional matters—but it was absolutely clear that everything was bad. And what's worse—without **talent!** He didn't love his own work, art, he wasn't, as they say, well suited to it. And so what now? He, it turns out, is a famous installer. At all exhibits, no matter where you drop in, he sets up chairs, turns on motors, something hums, whirls, some sort of boards are unfolded on the floor—but this is called a 'director,' a 'producer,' well, a 'designer' at the very most! And it is not surprising that hundreds of such 'creators' have sprung up all over the world, an entire 'epidemic'—neither labor is required, nor talent, nor a calling, nor skill, nor love for one's work! And of course, the galleries and curators and museum directors have all joined it, but note not one true art lover or connoisseur! Are there lots of installations in private collections? Almost none. There aren't many people who want to scatter garbage all around their house. They hang up 'paintings'! And the ease with which this young man turned the destroyed paintings into an original 'installation with a text' best indicates how this 'conspiracy' works. I am not touching upon the moral aspect of the matter at all, the fact that ripped paintings are the object of a tragedy of a real artist (I know him well), with what ease, as though nothing at all had happened, they can become the object of cold manipulation, a game, but this amorality is also a characteristic trait of what is happening now in general. . ."

Ingrid B., art historian:

"I do not agree at all with the respected artist, although I understand his anger and agitation very well. Whether you like or not, the history of art exists, and in it inevitably exists the replacement of some genres and types of art by others, moreover old types engender new ones which originate from them. And I advise you to look calmly and without excitement at where the installation comes from. The installation, in the form in which it exists today, has its origin in acts, happenings, performance art, it is rooted in them. In essence the installation is a leftover, a 'residue' if you wish, of that which has remained after an act has been performed. The biographies of all the contemporary masters of the installation provide examples of this: Beuys, Mario Merz, Kounnelis, and many others. They were great masters of performance art—and simultaneously or only later did they make installations. And any installation, if you look very carefully, contains inside of itself this memory of the acts, of the act, the event which served as the reason for its creation.

"And, to tell the truth, I really liked the idea of transforming the cut-up, destroyed paintings, now simply just a pile of garbage, into an installation, and it is not worth cursing it here. If you look objectively, it actually demonstrates the transition of one thing into another, the 'death' of painting leads to the 'birth,' the emergence, of the installation. It is very visual, and entirely instructive, and what is most important, entirely inevitable. And the fact that it was not the artist himself, i.e. the same one who destroyed his own paintings, who 'made' this, but someone else who didn't have anything to do with the making of the paintings, confirms even more the naturalness of this process."

Texts in the installation

Untitled, 1994, and *A Piece of Meat*, 1971?
Installation view

Untitled and A Piece of Meat

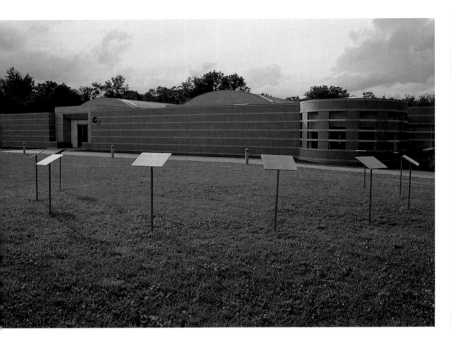 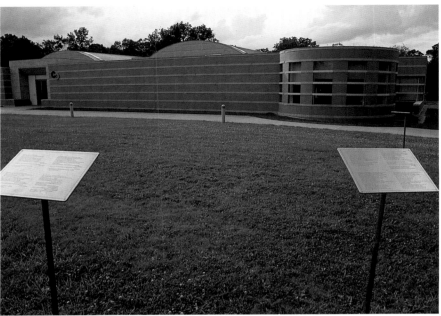

Monument to the Lost Glove

Monument to the Lost Glove, 1996
Installation views

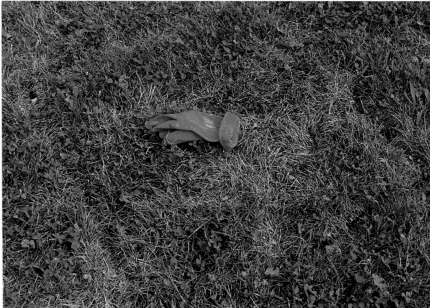

In the park, next to a narrow walking path covered with yellow sand, an old women's glove made of red leather lies in the grass, forgotten by someone. Nine metal tablets are placed on metal poles leaning toward the glove, which is in the center of this half-moon, around it, in a semi-circle that doesn't spill over onto the path. Externally this resembles a half-ring of music stands erected for a concert "in the open air."

As one approaches each of these tablet-music stands, what is on them becomes visible, and the texts are engraved on their metal surfaces in 4 languages: French, English, German and Russian. Each text—there are 9 in all, the same number as there are tablets—are utterances by various "personages" about the "lost glove" that they have seen in the grass. It's as though these are the utterances and thoughts that suddenly came into their heads, of course, in conformity with the personality of each, at the sights of the "unexpected discovery." Everything taken together forms a unique spectrum of internal images, memories and associations, not without, to a certain degree, humor, sadness and a certain poeticness—as is the case with everything that involves our memory. Herein lies the justification for the name of the installation *Monument to the Lost Glove*: any piece of nonsense, even a glove lost by someone, can acquire infinite value and significance if it is capable of touching something very important and dear to us in our memories, in our past.

Ilya Kabakov

. . .A lost red glove near the jogging path.

When I was young, I also ran along these paths.

We would run next to each other, we always ran together. . .

I tried never to fall behind him, and he would hold himself back so
 he wouldn't run too fast.

True, we ran here not in shorts and tee-shirts,

Like they do now, totally uninhibited. . .And their

Heads uncovered as well, their hair fluttering in the wind.

And I still remember when you couldn't even go outside

With an uncovered head. And we also ran in Panama hats with short
 round visors.

I had a favorite Panama hat with a wide blue ribbon.

Once, the wind blew it off as I was running, and it rolled around on
 the grass like a wheel. . .

He took off after it. . .caught it. . .and came back with the hat

And a large yellow rose in the other hand.

. . .Like two drops of water, it is identical to the one she left in the
 hotel. . .

The same kind of strap, the same color, reddish-orange.

We went for just two days, two days which we decided to spend
 together,

To be totally alone together, so that no one saw us alone together. . .

What time of year was that? The last days of summer? No, probably
 it was fall:

The little boat we decided to take a ride on was leaving on its last
 run, there was no one aboard it.

Or was it spring? I can't remember when it was;

I remember only the tears of happiness in her eyes that we were
 together,

But more out of grief that we would part again.

Tears from a sad book which she had brought with her and left,
 without finishing it,

And bitter tears over the forgotten glove, because she can't
 remember

How it could have happened and because it could never be returned
 again. . .

What a beautiful glove it was—I will buy myself one just like it,
I saw it at Rue Woges, I will buy an umbrella to match.
How pretty that is—long red gloves, a black suit, a small black hat. . .
It's settled—this summer I am going to visit Jean's parents in that
 outfit.
As always, there will be an outing in the carriage before supper. . .
But stop: Jeanine wore those exact same kind of gloves last summer.
Four red ones in one carriage will look a bit strange.
But perhaps she will come in different ones, or maybe she'll leave
 them at home or lose them. . .
Gloves are not in fashion this season. And what if she sees me
 wearing them?
Nonsense, I will think of something when I get there. For example:
I will say that Jean gave them to me as a gift right before I left,
And I didn't dare refuse to put them on.

No, I can't understand where the park administration is, what is it
 doing—
After all, someone should be looking after cleanliness!
The question is why is there all kinds of junk, scattered all over the
 place,
Dry branches, rocks on the paths, gloves lost by someone?
It's obvious that it is the responsibility of those who are riding all
 around in
Special little carts to look after cleanliness, but nonetheless,
They don't see what is lying right before their eyes.
They don't understand that it is shame on the city, especially if
 guests should come to visit us,
As they say, presidents of other countries—I heard about that,
But it's somehow hard to believe something like this—
What could they say about us, about the residents, if they
See garbage like this at their feet—I think
That they couldn't say anything good.
Of course, I could pick it up myself and throw it away,
But why should I do the work for them when they are getting paid
 for it?

Texts in the installation

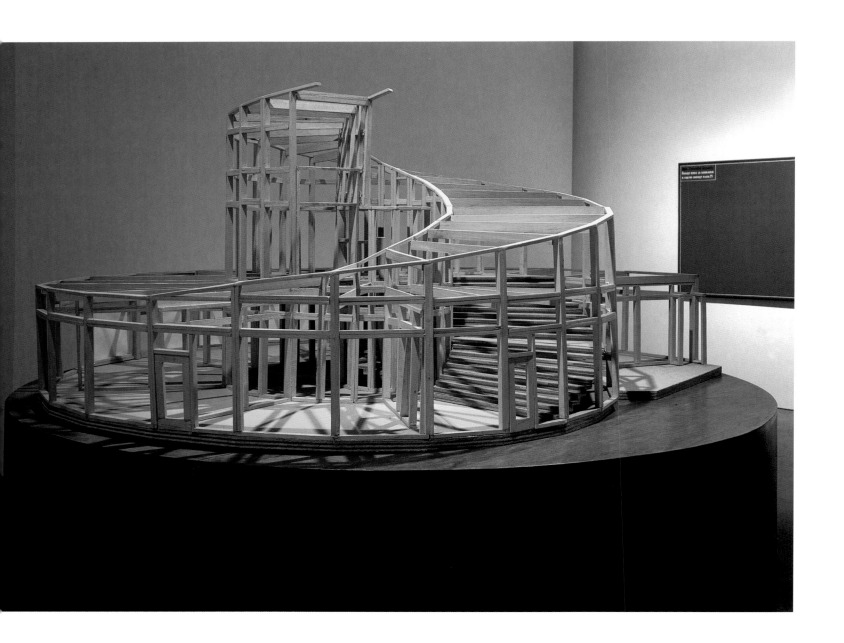

Ilya and Emilia Kabakov
The Palace of Projects, (model), 1998
Installation view

The Palace of Projects

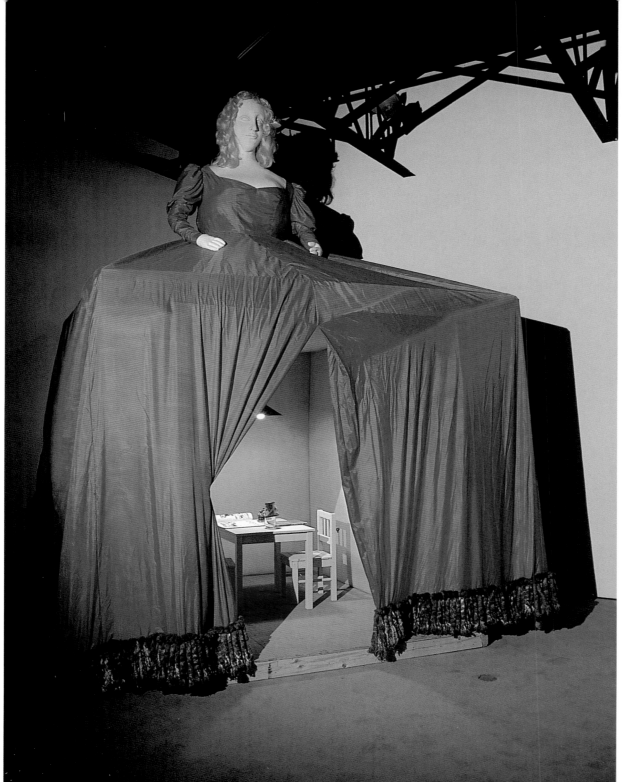

Reverse, 1998
Installation view

Reverse

Ilya Kabakov

Born 1933 in Dnepropetrovsk, Soviet Union
Lives and works in New York

Compiled by **Katherine Chan** and **Elaina Ganim**

Education/Prizes

1951
Studied at Moscow Art School

1957
Graduated from V. A. Surikov Art Academy, Moscow

1989
The Ludwig Prize, Friends of the Museum of Ludwig, Aachen

1992
The Arthur Kopcke Award, Kopcke Foundation, Copenhagen

1993
The Max Beckmann Prize, Frankfurt
The Joseph Beuys Prize, Joseph Beuys Foundation, Basel

1995
The Chevalier of Fine Arts Medal, Ministry of Culture, Paris

1997
Art Critics Association Award, New York
The Kaiserring Träger, Stadt Goslar

2000
Honorary Doctorate of Philosophy and Theory of Total Installation,
 University of Bern

Selected Solo Exhibitions

1985
"Along the Margins," Kunsthalle, Bern (traveled to Marseilles and Düsseldorf)
Dina Vierny Gallery, Paris

1986
"Concert for a Fly," Neue Galerie, Schlossli Gotzental, Dierikon, Switzerland

1987
"The '60s–'70s," Museum of Modern Art, Basel (with I. Tschuikov)
"Along the Margins," Centre National des Arts Plastiques, Paris

1988
"Ten Albums," Portikus-Ausstellung 9, Frankfurt (catalogue)
"Ten Characters," Ronald Feldman Fine Arts, New York City (catalogue)

1989
"White Covers Everything but Itself," De Appel, Amsterdam
"Exhibition of a Book," DAAD-Galerie, Berlin (catalogue)
"The Untalented Artist and Other Characters," Institute of Contemporary Art,
 London (catalogue)
"Ten Albums: Ten Characters," Riverside Studios, London
"Who Are These Little Men?" Institute of Contemporary Art, Philadelphia
"Communal Apartment/The Ship," Kunsthalle, Zurich (catalogue)
"The Beautiful '60s in Moscow," two-person exhibition with Michael Grobman,
 Genia Schreiber University Art Gallery, Tel Aviv University, Israel (catalogue)
"Two Albums," University of Saarbrücken, Germany
"Who Are These Little Men?" Galerie de France, Paris (catalogue)

1990
"The Ship," Neue Galerie of Museum Ludwig, Aachen, Germany
"Four Cities Project," Orchard Gallery, Derry, Ireland (catalogue)
"Seven Exhibitions of One Painting," Kasseler Kunstverein, Kassel, Germany
 (catalogue)
"He Lost his Mind, Undressed, Ran Away Naked," Ronald Feldman Fine Arts,
 New York City (catalogue)
"Ten Characters," Hirshhorn Museum and Sculpture Garden, Smithsonian
 Institution, Washington, D.C. (catalogue)

"The Rope of Life and Other Installations," Fred Hoffman Gallery, Santa Monica, Cal. (catalogue)

1991

"52 Entretiens dans la Cuisine Communitaire: Dialogue with Yuri Kuper," Ateliers Municipaux d'Artistes, Marseilles and Paris (traveled to Halle d'Art Contemporain, La Criée, Rennes, France) (catalogue)

"Ilya Kabakov: 3 Installations from Ten Characters" The Power Plant, Toronto (catalogue)

"The Targets," Peter Pakesch Gallery, Vienna

"My Motherland/The Flies," Werwerka and Weiss Galerie, Berlin (catalogue)

"Ripped-Off Landscape," Dresden Bank, Frankfurt (permanent installation)

1992

"The Life of Flies," Kölnischer Kunstverein, Köln (book)

"Ilya Kabakov: Incident at the Museum, or Water Music," music by V. Tarasov, Ronald Feldman Fine Arts, New York City

"Ilya Kabakov: He Lost His Mind, Undressed, Ran Away Naked," Krannert Art Museum and Kinkead Pavilion, University of Illinois, Urbana-Champaign.

"Unhanged Painting," Ludwig Museum, Köln (permanent)

"Illustration as a Way to Survive (installation in memory of Ulo Sooster)," Koninklijke Academie voor Schone Kunsten, Kortrijk, Belgium (catalogue)

"In Memory of Pleasant Recollections," Deweer Art Gallery, Otegem, Belgium (catalogue)

"Ilya Kabakov," Galleria Sprovieri, Rome (catalogue)

"On the Communal Kitchen, New Documents," Galerie Dina Vierny, Paris (book)

1993

"Ilya Kabakov—The Big Archive," Stedelijk Museum, Amsterdam (catalogue)

"The Boat of My Life," Kunstverein, Salzburg

"Communal Kitchen," Musée Maillol, Paris (permanent)

"NOMA (Moscow Conceptual Circle installation)," Kunsthalle, Hamburg (book)

"School N6," Chinati Foundation, Marfa, Texas (permanent)

"Incident at the Museum, or Water Music," music by V. Tarasov, Museum of Contemporary Art, Chicago (catalogue)

"The Red Pavilion," musical arrangement by V. Tarasov, Venice Biennale, Venice

"Concert for a Fly," music by V. Tarasov, Chateau d'Oiron, France (permanent)

"Illustration as a Way to Survive (installation in memory of Ulo Sooster)," Ikon Gallery, Birmingham, England

"Illustration as a Way to Survive (installation in memory of Ulo Sooster)," Centre for Contemporary Arts, Glasgow (catalogue)

"The Empty Museum," Staatliche Hochschule für Bildende Kunste-Stadelschule, Frankfurt am Main

1994

"The Red Corner," Kulturhuset, Stockholm

"Unrealized Projects," Kunstverein, Ludwigsburg, Germany (catalogue)

"Kabakov: Operation Room (Mother and Son)," National Museum of Contemporary Art, Oslo, and Museum of Contemporary Art, Helsinki (catalogue)

"Unrealized Projects," Exhibition Space, Reykjavík

"Ilya Kabakov: In the Apartment of Nicolai Victorovich," Jablonka Galerie, Köln

"Ilya Kabakov and Joseph Kosuth: The Corridor of Two Banalities," Center for Contemporary Art, Warsaw (catalogue)

"The Golden Underground River, The Boat of My Life, The Album of My Mother," Centre National d'Art Contemporain, Grenoble

"Incident at the Museum, or Water Music," music by V. Tarasov, Hessisches Landesmuseum, Darmstadt, Germany

"Artist's Despair, or Conspiracy of the Untalented," Barbara Weiss Gallery, Berlin

1995

"C'est ici que nous vivons/We are living here," Centre Georges Pompidou, Paris (book)

"The Collector," Galerie Thaddaeus Ropac, Paris (catalogue)

"Change of Scene VIII," Museum für Moderne Kunst, Frankfurt am Main (catalogue)

"The Boat of My Life, Unrealized Projects," Festspielhaus Hellerau, Dresden (catalogue)

"Incident at the Museum, or Water Music," Modern Art Center of the Calouste Gulbenkian Foundation, Lisbon

"The School Library," Stedelijk Museum, Amsterdam

"Ilya Kabakov: The Sea of Voices," Kunstmuseum, Basel (catalogue)

"The Bridge," Recalde Art Space, Bilbao (catalogue)

"No Water," Austrian Museum of Applied Arts, Vienna (permanent)

1996

"Ilya Kabakov: Storyteller," Koge Bugt Kulturhus, Copenhagen (catalogue)

"The Reading Room," Deichtorhallen, Hamburg (catalogue)

"On the Roof," Palais des Beaux-Arts, Brussels (book)

"Voices Behind the Door," Foerderkreis der Leipziger Galerie für Zeitgenössische Kunst, Leipzig (book)

"The Tennis Game," with Pavel Pepperstein, Porin Taidemuseo, Pori, Finland (catalogue)

"Books: A Retrospective with Drawings," Thea Westreich in collaboration with Barbara Gladstone Gallery, New York City

"Ilya Kabakov: Storyteller," Nordjyllands Kunstmuseum, Aalborg, Denmark

"Albums: Ten Characters," Künstlerhaus Schloss Balmoral, Bad Ems, Germany

"Music on the Water," music by V. Tarasov, Landeskulturzentrum Salzau, Kiel, Germany (book)

"The Garbage Man," National Museum of Contemporary Art, Oslo (book)

1997

"It Happens Tomorrow," Galerie Weisses Schloss, Zurich

"The Reading Room," Guild Hall Museum, East Hampton, N.Y. (catalogue)

"The Artist's Library," Satani Gallery, Tokyo

"The Life of Flies," Barbara Gladstone Gallery, New York City

"Monument to the Lost Glove," traffic triangle at Flatiron Building, temporary installation sponsored by Public Art Fund Inc., New York City

"Twenty Ways to Get an Apple, Listening to Mozart's Music," Moderna Galeria, Ljubljana, Slovenia (catalogue)

1998

"A Meeting: Jan Fabre and Ilya Kabakov," Deweer Art Gallery, Otegem, Belgium

"The Palace of Projects," with Emilia Kabakov, The Roundhouse, London (catalogue)

"16 Installations," Museum van Hedendaagse Kunst, Antwerp (catalogue)

"Treatment with Memories," Nationalgalerie im Hamburger Bahnhof, Museum für Gegenwart Kunst, Berlin (catalogue)

"The Collector," Thaddaeus Ropac Gallery, Salzburg (catalogue)

"The Metaphysical Man," Kunsthalle, Bremen (permanent) (catalogue)

"My Grandfather's Shed," Mönchehaus-Museum für Moderne Kunst, Goslar, Germany (permanent)

"The Children's Hospital," with E. Kabakov, Irish Museum of Modern Art, Dublin (permanent)

"Retrospective of Drawings and Albums," Stadtgallery, Heerlen, The Netherlands

"The Last Step," Bremenhaven, permanent installation, commissioned by the Federal Republic of Germany

1999

"The Life and Creativity of Charles Rosenthal," Art Tower Mito, Mito, Japan

"The Old Library", Fonds Noor de Kunst, Doelenzal of the University of Amsterdam

"*The Boat of My Life* and works from a private collection," Duke University Museum, Durham, N.C.

"Retrospective of Drawings," Sprengel Museum, Hannover

"Monument to the Lost Civilization," with Emilia Kabakov, Cantieri della Zisa, Palermo

"The Arriving Archive," Galerie der Stadt Backnang, Germany (catalogue)

2000

"Ilya Kabakov, Retrospective," Kunstmuseum, Bern (catalogue)

"The Palace of Projects," with Emilia Kabakov, The Armory on 26th St. and 1st Ave., New York City (catalogue)

"The Boat of My Life," Nexus Art Center, Atlanta

"Ilya Kabakov: 50 Installations," Wiesbaden Museum, Germany

"The Life and Creativity of Charles Rosenthal," Stadel Institut, Frankfurt (catalogue)

Selected Group Exhibitions

1965

"Contemporary Alternatives/2," Castello Spagnolo, L'Aquila, Italy

1966

"Sixteen Moscow Artists," Sopot Poznan, Poland

1967

"Young Moscow Artists," Renzo Botti Art Group, Cremona

"Fifteen Young Moscow Painters," Segno Gallery, Rome

1968

Exhibition with E. Bulatov, Blue Bird Café, Moscow

1969

"The New Moscow School," Pananti Gallery, Florence

"Moscow's New School," Behr Gallery, Stuttgart; Interior Gallery, Frankfurt

1970

"Today's Russian Avant-garde in Moscow," Gmurzynska Gallery, Köln

"New Tendencies in Moscow," Fine Arts Museum, Lugano, Switzerland

"Six Soviet Artists," R. Ziegler Gallery, Zurich

1973

"Russian Avant-garde: Moscow '73," Dina Vierny Gallery, Paris

1974

"Progressive Tendencies in Moscow (1957–1970)," Bochum Museum, Freiburg, Germany

1975

"Russian Nonconformist Artists (Glezer Collection)," Braunschweig, Freiburg, Berlin; traveled to Artists' Union, Vienna

"Seven from Moscow," Christian Brandstatter Gallery, Vienna

1976

"Contemporary Russian Painting," Palais des Congrès, Paris

"Russian Museum in Exile" (Glezer Collection), Montgeron, France

"Unofficial Russian Painting," Institute of Contemporary Art, London

"New Soviet Art, An Unofficial Perspective," Venice Biennale, Venice

"New Art from the Soviet Union," Arts Club of Washington, Washington, D.C.

"Art and Matter," Luxembourg Orangerie, Paris

"New Art from the Soviet Union," Herbert F. Johnson Museum of Art, Cornell University, Ithaca, N.Y.

1978

"Russian Nonconformist Painting," Saarland Museum, Saarbrücken, Germany

"New Soviet Art," Palazzo Reale, Turin

"Aspects and Documentation of Nonconformist Artists from the Soviet Union," Lodi, Italy

"New Unofficial Soviet Art," Centro d'Arte Contemporaneo, Bellinzona, Switzerland

1979

"Twenty Years of Independent Art from the Soviet Union," Bochum Museum, Bochum, Germany

"New Art from the Soviet Union: An Exhibition of Nonconformist Art from the 1960s and 1970s," St. Mary's College, Washington, D.C. (catalogue)

"Light, Form, Space," 28 Malaja Gruzinskaja, Moscow (catalogue)

"The Square's Fourth Dimension," Mart Gallery, Rockenberg, Germany

1981

"Twenty-Five Years of Soviet Unofficial Art, 1956–1981," Museum of Soviet Unofficial Art, Jersey City, N.J.

"Russian New Wave," Contemporary Russian Art Center of America, New York City

1982

"Contemporary Russian Painting 1971–1981," Gorky Galleries, Paris

28 Malaja Gruzinskaja, Moscow

Center of Technical Aesthetics, Moscow

Artists' Club, Kuznetskij Most, Moscow

1983

28 Malaja Gruzinskaja, Moscow

1984

State Museum of Tartu, Tartu, Estonia

1985

"Kunstsammlung: Jankilevsky, Kabakov, Steinberg," Bochum Museum, Bochum, Germany

"Ilya Kabakov's Everyday Art," Bielefeld University, Bielefeld, Germany (catalogue)

"Concert for a Fly," Castle Gotzental, Deitikon, Switzerland

1986

Kunstverein, Düsseldorf

"Ilya Kabakov: En Marge/Am Rande," Centre National des Arts Plastiques, Paris

"Die Wahlverwadtschaften, Steirischer Herbst '86," Palais Attems, Graz

1987

"The '60s–'70s," Museum für Gegenwartskunst, Basel

"Selections From the Kniga Collection," FIAC/Galérie de France, Paris

1988

"Ich Lebe, Ich Sehe: Künstler der Achtziger Jahre in Moskau," Bern Kunstmuseum, Bern (catalogue)

Bonn Kunstverein, Bonn

Venice Biennale, Venice

Arco 88, Madrid

1989

"The Ship," Art Contemporain ELAC, Lyon

"Magiciens de la Terre," Musée National d'Art Moderne, Centre Georges Pompidou, Paris (catalogue)

"Kosuth's Show," Sigmund Freud Haus, Vienna

"The Green Show," Exit Art, New York City

"Foto in Painting," First Gallery, Moscow

"Post Utopia: Paintings and Installations by Soviet Conceptualists: Bulatov, Kabakov, Komar and Melamid," Southeast Massachusetts University, North Dartmouth, Mass. (catalogue)

1990

"In the U.S.S.R. and Beyond," Stedelijk Museum, Amsterdam (catalogue)

"At Last, Freedom," DAAD-Galerie, Berlin (catalogue)

"Rhetorical Image," New Museum for Contemporary Art, New York City (catalogue)

"Soviet Art," Museo d'Arte Contemporanea, Prato, Italy (catalogue)

"Between Spring and Summer: Soviet Conceptual Art in the Era of Late Communism," Tacoma Art Museum, Tacoma, Wash. (catalogue)

"Works on Hanji Paper," Seoul Art Festival, Seoul (catalogue)

"Sydney Biennale 1990," Sydney (catalogue)

"The Green Show," Dunlop Art Gallery, Regina, Sask. (catalogue)

"The Quest for Self Expression: Painting in Moscow and Leningrad 1965–1990," Columbus Museum of Art, Columbus, Ohio

"Particular Histories," Butirskaja Jail, Moscow

"Soviet Contemporary Art 1990," Alpha Cubic Gallery, Tokyo (catalogue)

"Adaptation and Negation of Socialist Realism," Aldrich Museum of Contemporary Art, Ridgefield, Conn. (catalogue)

"The Readymade Boomerang: Certain Relations in 20th Century Art," 8th Biennale of Sydney (catalogue)

1991

"Wanderlieder," Stedelijk Museum, Amsterdam

"Weightless," Grosse Orangerie, Charlottenburg Palace, Berlin

"Soviet Art around 1990," Kunsthalle, Düsseldorf; traveled to Jerusalem (catalogue)

"Paintings from the Bible," The Bible Society, Frankfurt

"Kunst, Europa: Sowjetunion," Kunstverein Hannover, Hannover

"TRANS/Mission," Rooseum Center for Contemporary Art, Malmö, Sweden (catalogue)

"Art on Edge," Sezon Museum of Modern Art, Nagano (catalogue)

"New Directions," Zimmerli Museum of Art, New Brunswick, N.J.

"Dislocations," Museum of Modern Art, New York City (catalogue)

"Devil on the Stairs: Looking Back on the Eighties," Institute of Contemporary Art, Philadelphia

"Zero Gravity," Henry DeFord III Gallery, Long Island City, N.Y.

"Carnegie International," Carnegie Museum of Art, Pittsburgh (catalogue)

"In Public: Seattle 1991," Security Pacific Gallery, Seattle

"Soviet Contemporary Art: From Thaw to Perestroika," Setagaya Art Museum, Tokyo (catalogue)

Paris Nord Railroad Station, Paris

"Night Lines," Central Museum, Utrecht

"Contemporary Soviet Art," Auditorio de Galicia, Santiago de Compostela, Spain (catalogue)

"Perspectives of Conceptualism," University of Hawaii Art Gallery, Honolulu

"50 Artistes Pour le 25eme Anniversaire," La Cité Internationale des Arts, Paris (catalogue)

"Wittgenstein: The Play of the Unsayable," Wiener Secession, Vienna (catalogue)

1992

"EX USSR: Seven Artists from Russia," Groninger Museum, Groningen, The Netherlands

"Documenta IX," Kassel, Germany (catalogue)

"Parallel Visions: Modern Artists and Outsider Art," Los Angeles County Museum of Art

"A Mosca . . .A Mosca . . .," Villa Campolieto, Ercolano, Italy (catalogue)

Expo '92, Seville

"Devil on the Stairs," Newport Harbor Art Museum, Newport Beach, Cal.

"Blast Art Benefit," The X-Art Foundation and Blast, New York City (catalogue)

"Just Pathetic," American Fine Arts Co., New York City

"Soviet Art around 1990," Central House of Artists, Moscow (catalogue)

"About Painting—Encounter with History," Academie der Bildende Kunst, Vienna

1993

"Widerstand—Denkbilder für die Zukunft," Haus der Kunst, Munich

"Universalism and Particularism: The Russian World in Transition," Lehman College Art Gallery, Bronx, N.Y.

"Stalin's Choice: Soviet Socialist Realism 1932–1956," Institute for Art and Urban Resources at P.S. 1, Long Island City, N.Y.

"From Malevitch to Kabakov," Kunsthalle, Köln

"11th Annual Benefit Auction," Museum of Contemporary Art, Chicago (catalogue)

"From Chaos to Creation: Russian Art 1971–1992," Rye Arts Center, Rye, N.Y.

"Like a Body without a Shadow," Marsha Mateyka Gallery, Washington, D.C.

"Old Symbols/New Icons in Russian Contemporary Art," Stuart Levy Gallery, New York City

"The Language of Art," Kunsthalle Wien, Vienna

"Et Tous Ils Changent le Monde," Biennale d'Art Contemporain, Lyon

"After Perestroika: Kitchenmaids or Stateswomen," Independent Curators Incorporated, New York City

"Recycling through Art," Taejon Expo, Taejon, Korea (catalogue)

"Summer '93," Ronald Feldman Fine Arts, New York City

"The End of Empire, or the Experiments of Visual Poetry," Domaine de Kerguehennec, Centre d'Art Contemporain, Bignan, France

"From the Inside Out: Eight Contemporary Artists," The Jewish Museum, New York City (catalogue)

"Drawing the Line against AIDS," Peggy Guggenheim Collection, Venice (catalogue)

"adresse provisoire: pour l'art contemporain Russe," Musée de la Poste, Paris (catalogue)

"Het Depot," Galerie Akinci, Amsterdam

"Rendez (-) Vous," Museum van Hedendaagse Kunst, Gent (catalogue)

"At the Edge of Chaos: New Images of the World," Louisiana Museum of Modern Art, Humlebaek, Denmark (catalogue)

Galerie Bolag, Zurich

1994

Seoul International Art Festival, Seoul

"Virtual Reality," Biennale, Melbourne

"Do It," Kunsthalle Ritter Klagenfurt, Klagenfurt, Austria

"Face Off: The Portrait in Recent Art," Institute of Contemporary Art, University of Pennsylvania, Philadelphia (catalogue)

"Ivan Chuikov, Ilya Kabakov, Vadim Zacharov," Deweer Art Gallery, Otegem, Belgium

"Personal Stories: A History of the Universe," Hammond Galleries, Lancaster, Ohio

"Cloaca Maxima," Museum der Stadtentwasserung, Zurich

"Europa-Europa," Kunst- und Ausstellungshalle der Bundesrepublik Deutschland, Bonn

"Tyranny of Beauty—Architecture of the Stalinist Era," Austrian Museum of Applied Arts, Vienna

"The New York Studio Events Spring Benefit," Independent Curators Incorporated, New York City

"Don't Look Now," Thread Waxing Space, New York City

"Toponymies: Eight Ideas of Space," Fundacion "la Caixa," Madrid (catalogue)

1995

"Face-Off: The Portrait in Recent Art," Joslin Art Museum, Omaha (catalogue)

"Los Limites del Museo (The Ends of the Museum)," Fundació Antoni Tàpies, Barcelona

"Zeichen und Wunder (Signs and Wonder)," Haus der Kunst, Zurich

"Donald Judd and His Friends," Galerie St. Stephen, Vienna

Kwangju Biennale, Korea

International Art Festival, Rosamund Felsen Gallery, Los Angeles

"Dialogues of Peace," 50th anniversary of United Nations Palais des Nations, Geneva

"Kunst im Verborgenen," Lindenau Museum, Allenburg, Germany

"Orientation: The Vision of Art in a Paradoxical World," Fourth International Istanbul Biennial, Istanbul

"Hidden Art: Nonconformist Art from the Soviet Union," Jane Voorhees
Zimmerli Art Museum, Rutgers University, New Brunswick, N.J. (catalogue)
"52 Dialogues on the Communal Kitchen," Lefrac, France
"Hidden Art: Nonconformists in Russia 1957–1995," documenta-Halle, Kassel,
Germany
"Russian Jewish Artists in a Century of Change," The Jewish Museum, New York
City
"do it," Center for Contemporary Art, Glasgow
"Africus," Johannesburg Biennale, Johannesburg

1996
"From Figure to Object: A Century of Sculptors' Drawing," Frith Gallery,
London
"Les Pêchés Capitaux: La Paresse," Centre Georges Pompidou, Paris
"Le Cirque '96," Cirque d'Hiver, Paris, France
"Judenplatz: Wien 1996," Architectural Association, School of Architecture,
London
"Strangers in the Arctic," Porin Taidemuseo, Pori, Finland (catalogue)
"G7 Summit," Musée d'Art Contemporain, Lyon
"Urban Evidence: Contemporary Artists Reveal Cleveland," Cleveland Center for
Contemporary Art, Cleveland, Ohio
Ciccillo Matarazzo Pavilion, Bienal de São Paolo, Exhibition Universalis, São
Paolo, Brazil
Werwerka Gallery, Berlin
"Mahnmal und Gedenkstätte der Opfer des Naziregimes in Österreich
1938–1945," Kunsthalle Wien, Vienna

1997
"Artists for Sarajevo," Fondazione Bevilacqua La Masa, Venice
Henry Art Gallery, Seattle
"The Whitney Biennial," Whitney Museum of American Art, New York City
(catalogue)
"Meditations," Madraca Ibn Youssouf, Marrakech
"Face à l'Histoire, 1933–1996," Centre Georges Pompidou, Paris (catalogue)
47th Biennial of Venice (catalogue)
P.S. 1 Contemporary Art Center, Long Island City, N.Y.

1998
"Wounds: Between Democracy and Redemption in Contemporary Art," Moderna
Museet, Stockholm

"A Century of Artistic Freedom. 100 Years of the Vienna Secession," Secession,
Vienna
"Crossings/Traversées," National Gallery of Canada, Ottawa
"The History of the Interior," Stadel Institute, Frankfurt (catalogue)
"Goelag-Glasnost," Het Hessenhuis, Antwerp
"Change of Scene XIV," Museum für Moderne Kunst, Frankfurt
"Wasserspueren," Hannover Muenden, Hannover
7 Triennale der Kleinplastik, Stuttgart

1999
"World Artists at the Millennium," Elizabeth Foundation For the Arts at the
United Nations, New York City
"Millennium Messages," Heckscher Museum of Art, Huntington, N.Y., traveling
exhibition organized by the Smithsonian Institution, Washington, D.C.
(catalogue)
"Examining Pictures," Whitechapel Art Gallery, London; traveled to Museum of
Contemporary Art, Chicago
"Art Focus," Sultan's Pool, Jerusalem (catalogue)
Chianti Foundation, Marfa, Tex.
The Jewish Museum, Paris
"Monument to the Lost Glove," Les Champs-Elysées, Paris
"World Views: Maps and Art," Frederick R. Weisman Art Museum, University of
Minnesota, Minneapolis (catalogue)
"Der Tag Danach . . ." Collaboration Project/C, Theater der Welt '99, Berlin
"You Cannot Go Home: The Art of Exile," Brattleboro Museum and Art Center,
Brattleboro, Vt. (catalogue)
"Global Conceptualism," Queens Museum of Fine Arts, Queens, N.Y.
(catalogue)

2000
"L'Autre Moitie de l'Europe," Jeu de Paume, Paris
Tate Gallery, London
"Around 1984: A Look at Art in the Eighties," P.S. 1 Contemporary Art Center,
Long Island City, N.Y.
"Vision du Futur," Grand Palais, Paris (catalogue)

Selected Bibliography

Articles and Reviews

1966

Crispolti, E., "First Documents in Contemporary Avant-garde Painting and Plastic Arts in the Soviet Union," *Uomini e Idee* 7.1 (Jan./Feb.): 106–13.

Konecny, D., "The Problem of Technique in the Young Moscow Experimental School," *Prague-Moscow* 2.

1973

Chalupecky, J., "Moscow Diary," *Studio International* 185 (Feb.): 81–96.

1977

Glueck, G., "Art People," *New York Times* (7 Oct.): C18

Wierzchowska, W., and P. Wroblewska, "In the Studios of Moscow Graphic Artists," *Projekt* 4: 22–23.

1978

Szabo, A., "Ilya Kabakov: Glebovics Leo Trefari," *Új Müvézetért* 2: 34–35.

1980

Arean, C., "Arte de vanguardia en la URSS: zonas, tendencias y artistas mas significativos," *Goya* 157 (July/Aug.): 10–15.

Groys, B., "Ilya Kabakov," *A-Ya* 2: 17–22.

Patsyukov, V., "Project—Myth—Concept," *A-Ya* 2: 3–11.

1981

Bowlt, J., "Das Biel sind Bilder mit malerischen Werten," *Du* 6: 32.

Meier-Rust, K., "Schickt uns Ethnologen," *Du* 2.1: 68–69.

1984

Kabakov, I., "Dissertation on the Cognition of the Three Layers," *A-Ya* 6: 28–33.

———, "The Kitchen Series," *A-Ya* 6: 24–27

1986

Tupitsyn, M., "Ilya Kabakov," *Flash Art* 126 (Feb./Mar.): 67–69.

1987

Grout, C., "Ilya Kabakov: Along the Margins," *Flash Art* 132 (Feb./Mar.): 130.

Jolles, C., and V. Misiano, "Eric Bulatov and Ilya Kabakov," *Flash Art* 137 (Nov./Dec.): 81–83.

Pely-Audan, A., "Ilya Kabakov at Centre National des Arts Plastiques," *Cimaise* 34 (Jan./Feb.): 80.

Tupitsyn, M., "From Sots Art to Sovart," *Flash Art* 137 (Nov./Dec.): 75–80.

1988

Bonito-Oliva, A., "Neo-Europe (East)," *Flash Art* (International Edition) 140 (May/June): 61–64.

Cooke, L., "Aperto ma non troppo," *Art International* 4 (Autumn): 60–62.

Gookin, K., "Ilya Kabakov," *Artforum* 27.9 (Sept.): 135–36.

Heartney, E., "Ilya Kabakov at Ronald Feldman Fine Arts," *Art in America* 76 (Nov.): 179.

Kabakov, I., "La Pelle," *Cahiers du musée nationale d'art moderne* 26 (Winter): 4–110, supp. 1–69.

Tupitsyn, M., "Ilya Kabakov," *Flash Art* 142 (Oct.): 115–16.

Woodward, R., "Other Places, Other Rooms," *ARTnews* 87 (Sept.): 13–14.

1989

Bourriaud, N., "Magiciens de la Terre," *Flash Art* 148 (Oct.): 119–21.

Furlong, W., "The Unofficial Line: Ilya Kabakov," *Art Monthly* 125 (Apr.): 8–10.

Gambrell, J., "Perestroika Shock," *Art in America* 77.2 (Feb.): 124–35.

Hall, J., "Absurd Half-Life," *Apollo* 129 (June): 417–18.

———, "Rooms with a View," *Arena* (Spring): 38.

Huther, C., "Ilya Kabakov," *Das Kunstwerk* 41 (Feb.): 115–16.

Kowalska, B., "Zeitgenossische Kunst in der Sowjetunion," *Das Kunstwerk* 42 (June): 28.

Lloyd, J., "The Untalented Art: A Schizophrenic Way of Life," *Art International* 8 (Autumn): 70–73.

Martin, J.-H., "The Whole Earth Show," *Art in America* 77.5 (May): 153–55.

Morgan, S., "Kabakov's *Albums*," *Artscribe* (May): cover, 57–59.

Renton, A., "Ilya Kabakov," *Flash Art* 147 (Summer): 159–60.

Shepherd, M., "Erik Bulatov and Ilya Kabakov at ICA, London," *Arts Review* 41 (7 Apr.): 269–70.

Tupitsyn, M., "Veil on Photo: Metamorphoses of Supplementarity in Soviet Art," *Arts Magazine* 64 (Nov.): 79–84.

Watkins, J., "Ilya Kabakov," *Art International* 8 (Autumn): 65.

1990

Boym, C., "Reviving Design in the USSR," *Print* 44 (Mar./Apr.): 76–84.

Enders, A., "Ilya Kabakov," *Art and Antiques* 7 (Apr.): 131.

Gambrell, J., "Report from Moscow: The Perils of Peristroika," *Art in America* 3 (Mar.): 46–59.

Heartney, E., "Nowhere to Fly," *Art in America* 78 (Mar.): 176–77.

———, "Post-Utopian Blues," *Sculpture* 9.3 (May/June): 62–67.

Kachur, L., "Ilya Kabakov," *Art International* 11 (Summer): 71.

McCoy, P., "Ilya Kabakov," *Arts Magazine* 64 (Apr.): 85.

Nesbitt, L., "Ilya Kabakov," *Artforum International* 28 (Apr.): 172–73.

Tupitsyn, V., "Ilya Kabakov," *Flash Art* 151 (Mar./Apr.): 147.

Verzotti, G., "Doppel Jeopardy," *Artforum International* 29 (Nov.): 124–29.

1991

Archer, M., "Invisible Yearnings: The TSWA Four Cities Project," *Artscribe* 85 (Jan./Feb.): 60–63.

Bruderlin, M., "Ilya Kabakov," *Artforum International* 29 (Summer): 126.

Lorquin, B., "Ilya Kabakov," *Cimaise* 38 (Sept./Oct.): 57–64.

Palmer, L., ". . .And the wall came tumbling down," *High Performance* 14 (Spring): 36–39.

Tupitsyn, V., "From the Communal Kitchen: a Conversation with Ilya Kabakov," *Arts Magazine* 66 (Oct.): 48–55.

1992

Adams, B., "Ilya Kabakov," *Art in America* 80 (Dec.): 109.

Bonami, F., "Dislocations—The Place of Installation," *Flash Art* 25.162 (Jan./Feb.): 128.

Bouyeure, C., "A Day in His Life," *Cimaise* 39 (Sept./Oct.): 105–08.

Cotter, H., "Dislocating the Modern," *Art in America* 80 (Jan.): 100–05.

Danto., A., "Dislocationary Art," *The Nation* 255.1 (Jan.): 29–32.

Groys, B., "With Russia on Your Back," *Parkett* 34: 30–41.

Heartney, E., "Dislocations, MOMA," *ARTnews* 91.1 (Jan.): 117.

Jolles, C., "Kabakov's Twinkle," *Parkett* 34: 61–71.

Koplos, J., "Of Walls and Wandering," *Art in America* 80.7 (July): 82–87.

Kremer, M., "Matchboxes and Misconceptions," *Kunst & Museumjournaal* 4.2: 41–44.

Kuijken, I., "Documenta IX," *Kunst & Museumjournaal* 3.6: 1–11.

Pinchbeck, D., "Ilya Kabakov," *Art and Antiques* 9 (Oct.): 21.

Rosenthal, N., "Artists' Book Beat," *Print Collector's Newsletter* 23 (Nov./Dec.): 180–81.

Storr, R., "The Architect of Emptiness," *Parkett* 34: 42–51.

1993

Artner, A. G., "Beginning Again—A Soviet Artist Finds Painting is No Longer Enough," *Chicago Tribune* (25 July).

Bonami, F., "Ilya Kabakov," *Flash Art* 168 (Jan./Feb.): 87.

Decter, J., "Allegories of Cultural Criticism," *Flash Art* 170 (May/June): 118–19.

Deitcher, D., "Art on the Installation Plan," *Artforum*, 30.5 (Jan.): 78–83.

Esterow, M., "The Second Time Around," *ARTnews* 92 (Summer): 148–53.

Hofleitner, J., "Ilya Kabakov: The Boat of My Life," *Flash Art* 172 (Oct.): 98.

Virshup, A., "Russian Lessons," *ARTnews* 92 (May): 27.

1994

Bonami, F., "Ilya Kabakov: Tales from the Dark Side," *Flash Art* 177 (Summer): 91–93.

Groys, B., "Ilya Kabakov: Answers of an Experimental Group," *Artforum International* 33 (Sept.): 76–77.

Fayet, C., "Ilya Kabakov," *Artefactum* 11 (Autumn): 35.

Huther, C., "Ilya Kabakov," *Kunstforum International* 127 (July/Sept.): 372–73.

Muller, S., "Eastern European Art in Hamburg," *Flash Art* 175 (Mar./Apr.): 67.

Schumatsky, B., "Ilya Kabakov," *Du* 1 (Jan.): 40.

Suchin, P., "The Communal Connection: Ilya Kabakov and Contemporary Russian Art," *Art and Design* 9 (Mar./Apr.): 44–53.

Tupitsyn, M., "Against the Camera, for the Photographic Archive," *Art Journal* 53 (Summer): 58–62.

1995

Anselmi, I., "Dialogues de paix," *Kunstforum International* 132 (Nov./Jan.): 322–25.

Berringer, F., "Ghosts of a Vanished World," *ARTnews* 94 (Sept.): 134–36.

Gambrell, J., "Disappearing Kabakov," *Print Collector's Newsletter* 26 (Nov./Dec.): 171–74.

Jodido, P., "C'est ici que nous vivons," *Connaisance des Arts* 519 (July/Aug.): 5.

McEvilley, T., "Look Homeward, Angel (You Can't Go Home Again): Some Nomadic Artworks of the Post-Soviet Era," *Parkett* 45: 173–80.

Rian, J., "Ilya Kabakov at Centre Pompidou, Thaddeus Ropac," *Flash Art* 184 (Oct.): 114.

Storr, R., "An Interview with Ilya Kabakov," *Art in America* 83 (Jan.): 60–69.

Tupitsyn, V., "A Psychodrome of Misreading," *Third Text* 33 (Winter): 25–30.

1996

Hyman, S., "Ilya Kabakov," *Sculpture* 15 (May/June): 77–78.

1997

Borja-Villel, M. J., "Musee-Museum," *Lotus International* 95: 46–59.

Boym, S., "Ilya Kabakov," *Artforum International* 35 (Summer): 127.

Kimmelman, M., "Narratives Snagged on the Cutting Edge," *The New York Times* (21 Mar.): C1.

Turner, G., "Ilya Kabakov at Barbara Gladstone," *Artforum International* 35 (Summer): 127.

Zinik, Z., "The Past is Another Installation: Interview with Ilya Kabakov," *Modern Painters* 10 (Winter): 56–60.

1998

Bartelik, M., "Ilya and Emilia Kabakov," *Artforum International* 36.10 (Summer): 143–44.

Hunt, I., "The People's Palace," *Art Monthly* 216 (May): 9–12.

Man, S., "Ilya and Emilia Kabakov: *The Palace of Projects,*" *Third Text* 43 (Summer): 96–98.

Melvin, J., "Giving a Sense of Secret Lives: Ilya and Emilia Kabakov's *Palace of Projects,*" *Architect's Journal* 207.13 (2 Apr.): 68.

Peaker, C., "Ilya and Emilia Kabakov: The Roundhouse, London," *C Magazine* 59 (Sept./Nov.): 50.

Rabinowitz, C., "Ilya Kabakov: Treatment with Memories," *Art Papers* 22.6 (Nov./Dec.): 67–68.

Schwabsky, B., "Ilya and Emilia Kabakov: The Roundhouse, London," *Art Text* 62 (Aug./Oct.): 78–79.

Storrie, C., "The People's Palace," *Blueprint* 150 (May): 48.

1999

Breyhan, C., "Ilya Kabakov: die Philosophie des Mulls," *Kunstforum International* 146 (July/Aug.): 300–11.

Codognato, M., "Ilya and Emilia Kabakov: Cantieri Culturali Alla Zisa," *Artforum International* 38.3 (Nov.): 150.

Jeffreys, D., "Colchester, Exeter and Dublin: Yoko Ono, Gustav Metzger and Ilya Kabakov," *The Burlington Magazine* 141 (Apr.): 242–43.

Meinhardt, J., "Ilya Kabakov: zwei Folgen aus *Ten Characters,*" *Kunstforum International* 147 (Sept./Nov.): 420–22.

Midgett, A., "Neuroses and Nostalgia," *ARTnews* 98.11 (Dec.): 141.

Schlegel, A., "The Kabakov Phenomenon," *Art Journal* 58.4 (Winter): 98–101.

2000

Johnson, K., "Indoor/Outdoor Relations along the Hudson Valley," *New York Times* (21 July): 33.

Ramirez, J.-A., "Spiral of Utopias," *A + U* 352 (Jan.): 12–23.

Artist's Books, Monographs and Exhibition Catalogues

1985

Jankilevskij, Kabakov, Steinberg. Bielefeld: University of Bielefeld/Bochum: Museum Bochum, with texts by Boris Groys, H. Günther, and H. Hüttel.

Kabakov, Ilya. *Okno/Das Fenster/The Window*, with texts by Claudia Jolles, Ilya Kabakov and Jean-Hubert Martin. Bern: Benteli Verlag, 1985.

1986

Kabakov, Ilya. *Ilya Kabakov: En Marge [Along the Edge]*, Galerie de la Vieille-Charité, with texts by Boris Groys and Jean-Hubert Martin. Marseilles: Musées de Marseilles.

1987

Contemporary Soviet Art: Selections from the Kninga Collection. Paris: Galerie de France.

1988

Kabakov, Ilya. *Vor dem Abendessen*. Graz: Grazer Kunstverein.

10 Alben. Porticus-Austellung 9. Frankfurt: Porticus.

Ten Characters. New York: Ronald Feldman Fine Arts.

1989

Exhibition of a Book. Berlin: DAAD Galerie.

Foto in Painting. Moscow: First Gallery.

The Green Show. New York: Exit Art.

MacFarlane, K. *Ten Albums/Ten Characters*. London: Riverside Studios and Institute of Contemporary Art.

Novostroika: New Structures in the Soviet Union Today. London: Institute of Contemporary Art.

Que sont ces petits hommes? Paris: Galerie de France.

Das Schiff—Die Kommunalwohnung, Zwei Installationen von Ilya Kabakov. Zurich: Kunsthalle.

1990

Adaption and Negation of Soviet Socialist Realism: Contemporary Soviet Art. Ridgefield, Conn.: Aldrich Museum of Contemporary Art.

Between Spring and Summer: Soviet Conceptual Art in the Era of Late Communism. Tacoma, Wash.: Tacoma Art Museum; Boston: Institute of Contemporary Art.

He Lost His Mind, Undressed, and Ran Away Naked. New York: Ronald Feldman Fine Arts.

Rhetorical Image. New York: New Museum for Contemporary Art.

The Rope of Life. Santa Monica, Cal.: Fred Hoffman Gallery.

7 Ausstellungen eines Bildes. Kassel, Germany: Kasseler Kunstverein.

Ten Characters. Washington, D.C.: Hirshhorn Museum and Sculpture Garden, Smithsonian Institution.

1991

Art on Edge. Nagano: Sezon Museum of Modern Art.

Carnegie International. Pittsburgh: Carnegie Museum of Art.

Contemporary Soviet Art. Santiago de Compostela, Spain: Auditorio de Galicia.

Devil on the Stairs: Looking Back on the Eighties. Philadelphia: Institute of Contemporary Art.

Ilya Kabakov/John Scott. Toronto: The Powerplant.

Ilya Kabakov: Meine Heimat (Die Fliegen). Berlin: Wewerka und Weiss Galerie.

Ilya Kabakov/Yuri Kuper: 52 Entretiens dans la Cuisine Communautaire. Marseilles: Atelier Municipaux d'Artistes.

Kabakov. Paris: Galerie Dina Vierny.

Kabakov, I., and B. Groys. *Die Kunst des Fliehens: Dialogue über Angst, das heilege Weiß und den sowjetischen Müll.* München/Wien: Carl Hanser Verlag.

Soviet Art around 1990. Düsseldorf: Düsseldorf Kunsthalle.

Soviet Contemporary Art: From Thaw to Perestroika. Tokyo: Setagaya Art Museum.

Storr, R. *Dislocations.* New York: Museum of Modern Art.

Words Without Thoughts Never to Heaven Go. Utrecht, The Netherlands: Centraal Museum.

1992

A Mosca… a Mosca… Ercolano, Italy: Villa Campolleto; Bologna: Galleria Communale d'Arte Moderna.

Documenta IX. Kassel, Germany.

Illustration as a Way to Survive. Gent: Kanaal Art Foundation.

Ilya Kabakov. Rome: Galleria Sprovieri.

In Memory of Pleasant Recollections. Otegem, Belgium: Dweer Art Gallery.

Das Leben der Fliegen/ The Life of Flies. Köln: Kolnischer Kunstverein, Edition Cantz.

1993

Addresse provisoire: pour l'art contemporaine Russe [Temporary Address: For Contemporary Russian Art]. Paris: Musée de la Poste.

At the Edge of Chaos—New Images of the World. Humlebaek, Denmark: Louisiana Museum of Art.

Beck, H. *The Rope of Life and Other Installations.* Frankfurt: Museum für Moderne Kunst.

Francis, R. *Incident at the Museum, or Water Music.* Chicago: Museum of Contemporary Art.

From the Inside Out. New York: The Jewish Museum.

The Language of Art. Stuttgart: Cantz.

Rendez(-)Vous. Gent: Museum van Hedendaagse Kunst.

Russische Avantgarde im 20. Jahrhunderte. Köln: Museum Ludwig.

1994

don't look now. New York: Thread Waxing Space.

Face-Off: The Portrait in Recent Art. Philadelphia: Institute of Contemporary Art.

Ilya Kabakov/Joseph Kosuth: The Corridor of Two Banalities. Warsaw: Centre for Contemporary Art, Ujazdowski Castle.

Stalin's Choice: Soviet Socialist Realism, 1932–1956. New York: Institute for Contemporary Art, P.S. 1 Museum.

Toponimias: Eight Ideas of Space. Madrid: Fundación "La Caixa."

1995

Ilya Kabakov: Installations, 1983–1995. Paris: Centre Georges Pompidou.

Obrist, H.-U. *do it.* Paris: Association Française d'Action Artistique.

Russian Jewish Artists in a Century of Change, 1890–1990. Munich, New York: Prestel.

1996

Le Navire/The Ship. Lyon: Musée d'Art Contemporaine.

Wallach, A. *The Man Who Never Threw Anything Away.* New York: Harry N. Abrams.

1997

Bertola, C. *Sarajevo progetto culturale internazionale.* Venezia: Arsenale Editrice, 1997.

Obrist, H.-U. *do it.* Copenhagen: Kommunes Udstillingsbygning.

1998

Bex, F. *16 Installations.* Antwerp: Museum van Hedendaagse Kunst Antwerpen.

Deumens, J. *Ilya Kabakov: Drawings.* Hannover: Sprengel Museum.

Fineberg, J. D. *The Boat of My Life.* Champaign: Krannert Art Museum and Kinkead Pavillion, University of Illinois at Urbana-Champaign.

Groys, B. *Ilya Kabakov.* London: Phaidon.

Ilya Kabakov zur verleihung des Goslarer Kaiserrings. Goslar, Germany: Mönchehaus-Museum für Moderne Kunst Goslar.

Popiashvili, I. *Remembering Times Past.* New York: Apex Art Curatorial Program.

Wallach, A. *Ilya Kabakov.* London: Phaidon.

1999

Bertola, C., and P. Falcone. *Monument to a Lost Civilization.* Milan: Edizioni Charta.

Ilya Kabakov: The Old Reading Room. Amsterdam: Vossiupers AUP.

Michailov, B. *Case History.* Zurich and New York: Scalo.

2000

Bonito-Oliva, A. *Stanze e segreti.* Milan: Rotunda della Besana.

Felix, Z. *The Text as the Basis of Visual Expression.* Köln: Oktagon Verlag.

Ilya Kabakov: 50 Installations. Bern: Kunstmuseum Bern.

Schick, M. *The Arriving Archive.* Ostfildern-Ruit, Germany: Hatje Cantz; New York: Distributed Art Publishers.

Sobel, D. *Interventions: New Art in Unconventional Spaces.* Milwaukee: Milwaukee Art Museum.